Savannah's
Little Crooked
Houses

Savannah's
Little Crooked
Houses

If These Walls Could Talk

Susan B. Johnson

Charleston London

History
PRESS

Published by The History Press
Charleston, SC 29403
www.historypress.net

Copyright © 2007 by Susan B. Johnson
All rights reserved

Cover image: 536 East State Street.

First published 2007

Manufactured in the United Kingdom

ISBN 978.1.59629.226.0

Library of Congress Cataloging-in-Publication Data

Johnson, Susan B. (Susan Belt), 1934-
 Savannah's little crooked houses : if these walls could talk / Susan B.
Johnson.
 p. cm.
 Includes bibliographical references.
 ISBN 978-1-59629-226-0 (alk. paper)
 1. Historic buildings--Georgia--Savannah. 2. Cottages--Georgia--Savannah.
3. Savannah (Ga.)--Buildings, structures, etc. 4. Savannah
(Ga.)--Biography. 5. Savannah (Ga.)--History. I. Title.
 F294.S2J638 2007
 975.8'724--dc22
 2006036774

For Fred—another first

Buildings are three-dimensional history books that reflect the comings and goings,
successes and failures, aspirations and follies of real people.
—*Mills Bee Lane IV,* Architecture of the Old South

There was a crooked man, and he went a crooked mile,
He found a crooked sixpence against a crooked stile;
He bought a crooked cat, which caught a crooked mouse,
And they all lived together in a little crooked house.
—Anonymous

Contents

Acknowledgements

If not for the good fortune of having the Georgia Historical Society in my own backyard, this book would not exist. My thanks to its knowledgeable staff who, for nearly three years, helped me dig through dusty archives and locate ancient newspapers on microfilm.

I am also grateful to librarians Sharen Lee and Barry Stokes for guiding me through the maze that is the Georgia Room at Savannah's Live Oak Library—another treasure trove for historical researchers.

To my friend Bill Durrence for his extraordinary patience and photographic expertise, I owe my thanks.

But the largest portion of gratitude goes to my husband, Fred Johnson, who for six months sailed me around the Chesapeake Bay, anchored me in quiet coves and cheered me on while I wrote the first draft.

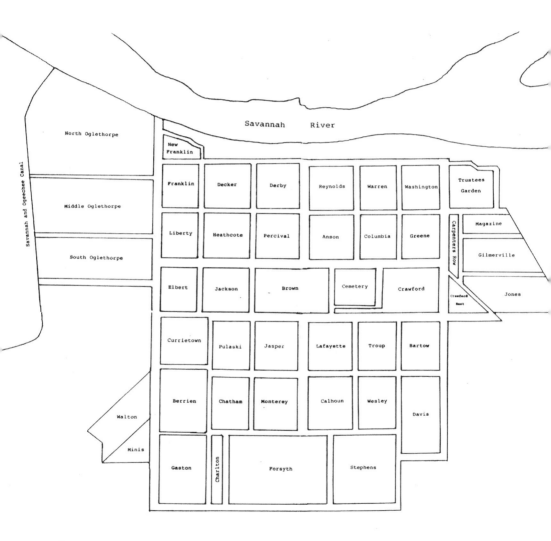

Reproduction of the 1860 Census Map of Savannah. *Courtesy of Georgia Historical Society.*

Introduction

I magine.

It is July 3, 1802, and you stand in the open doorway listening to the night sounds—the whimper of a child up in the sleeping loft, the rumble of distant thunder, the whinny of a horse from the stable down the street. Your hand rests on the door frame of the house you have occupied for the last three years, a sturdy cottage built of local heart of pine. Again you hear thunder and are glad for the promise of rain. Too many people, especially children, have fallen ill from the heat.

You step out onto the low stoop, hoping for a breeze, but not a leaf stirs and the dust from the street hangs in the motionless air. In the neighboring houses—four-room cottages like yours—all lanterns have been extinguished for the night. Of the several thousand people in Savannah, it seems you alone are awake.

Tomorrow you will join your neighbors on the common to celebrate America's twenty-sixth year of independence from British rule. You look forward to the pageantry—the fifes and drums, the military parades and even, it is rumored, the flight of a hot air balloon. Your mouth waters in anticipation of wild pig roasted on a spit, steamed oysters and Indian pudding. You are proud of your thriving city and hope that soon your new president, Thomas Jefferson, will visit Savannah just as President Washington did in 1791.

With a sudden crack of thunder, the sky opens and the torrent pounds on the wooden shingles, gullies the rutted dirt street. No houses will be ravaged by fire tonight, you think, grateful that your own family sleeps safely on their straw-filled mattresses. And with luck the rain will quell the pestilence that invites summer's dreaded yellow fever.

You take one step forward, breathe deeply of the new-washed air and lift your face to the rain.

Introduction

Detail of Peter Gordon's *A View of Savannah As It Stood on the 29th of March 1734. Courtesy of the Georgia Historical Society.*

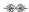

Peter Gordon's drawing *A View of Savannah As It Stood the 29th of March 1734* shows row after row of tiny cottages constructed from whatever building materials the first settlers had at hand—largely pine and cypress. Although unimaginative, the architecture served the purpose—four small rooms quickly constructed and easily heated by a fireplace. The design must have worked well as hundreds of similar low-cost dwellings were built in the city over the next century.

But because these early cottages were constructed of combustible materials, fire was a constant concern. Over a period of eighty-seven years, five major conflagrations destroyed large portions of Savannah's community of wooden buildings.

In 1796, for instance, fire broke out in a baker's shop near the public market and spread in all directions, destroying 229 houses and causing over $300,000 worth of damage. Some of Savannah's 6,226 residents had to move their belongings seven different times!

Again, in 1820, fire consumed 463 houses plus numerous outbuildings, including the public market and the offices of the *Daily Georgian.* Damages were estimated at $4 million.

Introduction

Another fire in 1852 burned nearly the whole of the area from Harrison to Pine Streets and from West Broad to Farm (later Fahm) Street.

During the harassment and oppression inflicted by Sherman's occupying army in 1865, fire consumed more than a hundred buildings and nearly destroyed the city when a former Confederate arsenal went up in flames. Hour after hour the exploding cartridges launched cannon and musket balls in every direction, and in the end, the city was ravaged from Harrison to Pine Streets, from Congress to Broughton and from St. Gall to Montgomery.

The last of the great Savannah fires burned the area known as Yamacraw in 1883, destroying 312 buildings and leaving 1,278 people homeless—a $1-million loss.

But fire wasn't the only threat. On occasion Mother Nature unleashed her wrath upon Savannah. On September 8, 1804, a fierce "tempest" swept through the city, uprooting trees and blowing away houses. Many of the riverfront warehouses were demolished and eighteen vessels in the harbor were thrown upon the wharves. Not only were the "exchange" (city hall), the "filature" (silk-reeling factory), the jail and the courthouse damaged, but several Savannahians also lost their lives.

Although over the last 270 years many of Savannah's early wooden buildings have been lost, a great number of stalwart eighteenth- and early nineteenth-century structures still stand in proud testament to her history. Included among these are some of Savannah's smallest dwellings—the antebellum cottages of Washington, Warren, Greene and Chatham Wards. All are one- or one-and-a-half-story, free-standing frame houses of 1,200 square feet or less. Each is still home to a Savannah family.

But who were the first to own them, to raise their children beneath their shingled roofs, to watch from their windows the dust rising on an August afternoon? What frightened families huddled inside them during the great Yellow Fever epidemics of 1820 and 1876? Who were the women who tended their hearths while their menfolk fought at Gettysburg? They were brave and cowardly, faithless and true, selfish and selfless—in other words, men and women just like you and me.

The following pages celebrate the colorful and often tragic lives of those who built, owned, lived and died in Savannah's tiniest treasures—ten little crooked houses that have withstood the test of time.

E. Bryan Street

Lincoln Street

Habersham Street

E. Congress Street

E. Congress Lane

Habersham Street

E. Broughton Street

E. Broughton Lane

Lincoln Street

E. State Street

Habersham Street

E. President Street

E. York Street

Habersham Street

E. York Lane

E. Oglethorpe Avenue

W. Gordon Street

Whitaker Street

W. Gordon Lane

9

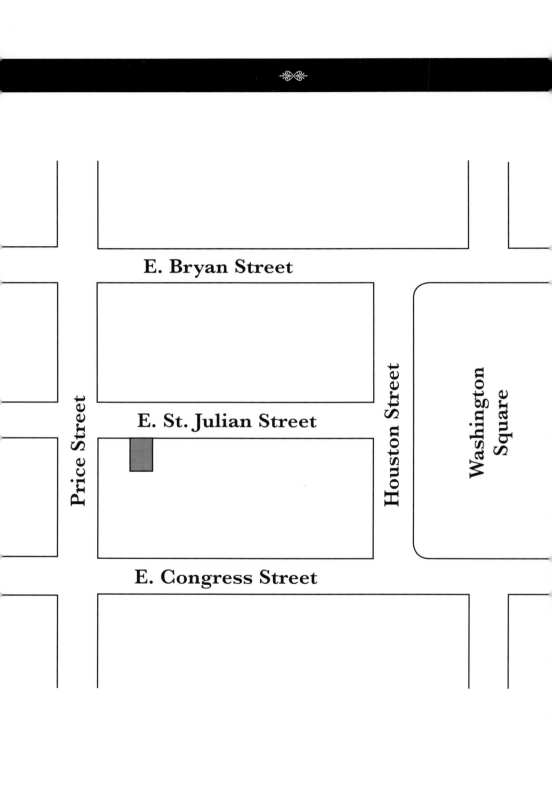

503 East Saint Julian Street
Washington Ward

Tucked between its taller neighbors, this low stoop house is easily overlooked. At first glance its small scale seems more appropriate for a child's playhouse than for a family home. Yet inside a sense of space prevails. As you climb the five steps to the tiny front porch, you notice fern-filled window boxes beneath the two mullioned windows overlooking Saint Julian Street, whose broad, tabby surface often echoes with the clip-clop of carriage horses.

Built entirely of heart pine, the cottage mirrored the plan of dozens of other small Savannah dwellings built from the late 1700s to the middle 1800s—four small rooms and a path to the privy. Step into the living room, which was once two smaller rooms that served as living and sleeping quarters. Now the dividing walls are gone, creating a generous space in which contemporary art and furnishings of leather, chrome and glass blend with the original heart pine floors and wainscot. Warm yourself by the

wood-burning fireplace in the corner, originally providing the house's only source of heat. Beyond is a dining room with its wall of bookcases and a parson's table that can seat eight comfortably. The powder room tucked behind the chimney—site of the old kitchen—occupies the remaining space of the original downstairs. Now, however, a short hall leads to a large, modern kitchen and utility room added in 1982.

Step out the back door onto the canopied redwood deck and hear the music of the fountain playing in the middle of the walled garden. Notice how the flower beds, bright with purple vinca and pink impatiens, are bordered with blocks of Belgian granite used originally as ballast in the sailing ships of old. The marmalade cat asleep in the shade of the Savannah holly tree will forgive your intrusion.

Typical of the early cottages, a ladder once led to the dark sleeping loft beneath the eaves, where an opposing pair of small dormers provided the only relief from the torrid summer heat. Today, a staircase off the living room brings you to the single large bedroom and bath—made bright and airy when the pitch of the rear roof was altered to accommodate the addition of four double-hung windows.

When the cottage was rescued from twenty-six years of dereliction, the exterior architecture remained essentially unchanged. Although heart pine shakes that made up the old roof were replaced with new cedar ones, much of the two-hundred-year-old clapboard and old window glass was carefully preserved—two of the reasons why the cottage won Historic Savannah Foundation's award for Excellence in Residential Restoration in 1984.

The story of this little crooked house began in May 1791, when President George Washington made a four-day visit to Savannah, and her 6,226 inhabitants bid him welcome with much ceremony. Just four months earlier, the city limits had extended east to Lincoln Street,[1] west to Jefferson and south from the river to South Broad (now Oglethorpe Avenue). At that time, most of the 618 houses, 415 kitchens, 228 outhouses, stores and shops were constructed of wood. Only five dwellings existed on South Broad's north side and none on the south, which was marshy and more suitable for the cultivation of rice.

But in January 1791, perhaps in anticipation of the president's visit, portions of the surrounding grassy "commons" were annexed to the city, forming three new wards—Franklin, Warren and Washington—each divided into lots and named for the square to which it belonged. Title to one of those lots, number 24 Washington Ward, was granted by the city to Edward J. Harden (1757–1804).

Although no documentation exists confirming the exact date of construction, it is likely that between the late 1790s and 1808, Harden built

four identical cottages—501, 503, 505 and 507 East Saint Julian Street—for in 1808 taxes were paid on "buildings" there, affirming their existence at least one year earlier. According to local lore, one of the cottages eventually burned, another collapsed and a third was demolished. Today, more than two hundred years later, only this one of Edward Harden's little crooked houses remains.

Harden fought with the First Georgia Regulars in the Revolutionary War and, by its end, had achieved the rank of major. He was a successful lawyer and planter who, through inheritance and savvy, had acquired extensive lands in the Savannah area, including Nathanael Greene's famous Mulberry Grove Plantation, where the Greene family's guest, Eli Whitney, built his first cotton gin in 1793.

During the post-Revolutionary depression of 1796–1815, Greene's widow, Catherine, fell on hard times and, to satisfy her creditors, was forced to sell at auction Mulberry Grove's several houses, five hundred acres of river swamp, two hundred acres of arable upland and two thousand acres of oak, hickory and pine timberland. Edward Harden bought the entire plantation for the paltry sum of $15,000. He immediately borrowed $5,000 to improve the canals, embankments and floodgates of his new property, using the plantation itself as collateral.

But Edward wanted more than real estate—he wanted a family—so he married Jane Reid, and together they produced six children: Edward, John Eberson, William Reid, Robert, Thomas Barton and Jane. It was a proud day for Edward when his eldest son and namesake joined him in the practice of law. By 1804 the two Edwards had formed the partnership of Harden and Harden, Attys., with an office on Broughton Street.

In many ways, Major Harden was a civic leader who left an indelible mark upon the city of Savannah. He was elected a member of the General Assembly for Chatham County in 1801, the same year the legislature passed an act to order the laying out of public roads and to plan for the building and maintaining of the public bridges. As one of the justices of the Inferior Court of Chatham County, Harden was appointed overseer of Augusta Road, a heavily trafficked dirt road in the northwest division. This position required mobilizing a maintenance crew from among all free male inhabitants between the ages of sixteen and forty-five years and all male slaves within his district. These unpaid workers were made liable by law and subject to Major Harden's orders and direction.

However good it looked on paper, the plan proved unworkable. Ill-equipped, unpaid and therefore unmotivated, Harden's workforce required more supervision than a busy lawyer, politician, planter and family man could provide, and in 1804, he and three other justices pronounced the

Savannah's Little Crooked Houses

Augusta Road almost impassable, due to potholes, rutted wagon tracks and mud. As a result, the court ordered the hiring of laborers to be paid seventy-five cents apiece per day out of a new tax levied in 1803 specifically for that purpose. This was the first step toward the formation of Savannah's current Bureau of Streets and Sanitation.

Like many prominent and concerned citizens of the time, Harden served successive terms from 1799 to 1803 as alderman of Washington Ward, which included his four cottages. Both ward and square had been named for George Washington in 1791 during the president's visit to Savannah as part of his Southern Tour. An avowed admirer of Washington, Harden was appointed by the City Council to oversee the erecting of a marble monument in Johnson Square commemorating the president, its cost not to exceed $3,000. The budget may have proved inadequate, however, for this task was never accomplished, and today a monument to patriot Nathanael Greene stands there instead.

When Hampton Lillibridge, Harden's friend and fellow planter, fell ill in 1797, he appointed Harden and Harden, Attys., to represent him during his absence from his office, referring all persons having pressing business to apply to them in his stead. Two years later when Lillibridge died, Edward served as executor of his friend's estate.

By an odd twist of fate, the famous haunted Lillibridge house was moved in 1962 from its original site at 310–312 East Bryan Street to its present location at 507 East Saint Julian, replacing two of Harden's four little houses. As a result, today—more than two hundred years after their deaths—the two friends' houses stand side by side.

Even with the Revolutionary War seventeen years in the past, life in 1800 was not without problems in this growing city of five hundred mostly frame structures. Fire remained a threat, sometimes destroying an entire block at a time. Slaves on whose labor the economy depended were often recalcitrant and required constant vigilance. Primitive medical methods and lack of sanitation caused the deaths of many of its citizens—especially children—from such diseases as *trismus nascentium*, denge (or "broke bone fever"), gravel (kidney stones), phoenitis (or "frenzy"), quinsey (tonsillitis) and scorbutic humor (scurvy). Few were the families who did not lose at least one member to yellow fever during the frequent summer scourges.

During the first twenty years of his marriage, however, Edward Harden was fortunate to have a flourishing family, a thriving law practice and only minor problems. In 1801, for example, one of his best horses, a mare that stood fifteen hands high and bore a scar below her right fetlock, was stolen from the Eastern Common, an undeveloped grazing area (now partly

occupied by the Fred Wessels public housing complex). Whether or not someone came forward to claim Harden's offer of a ten-dollar reward is anybody's guess.

During the same year the city surveyor found that Harden's riverfront property—wharf lot no. 2 between Habersham and Lincoln Streets, known as Coffee House Wharf—encroached over three feet beyond the line marking low water. As a consequence, the city council directed him to remove this encroachment within three months or it would be removed at his expense.

The Harden family's good fortune ended in the summer of 1804. A yellow fever epidemic swept across the South claiming many lives, including that of Edward Sr. He was still a young man of forty-seven when he died on July 9, his wife's forty-fourth birthday. His will bequeathed his handsome estate to his "darling wife, Jane."

Four weeks later, all of Savannah watched in horror as the sky turned greenish gray and the air became choked with dust. Soon the first chill drops of rain fell like needles, quickly becoming a torrent that flooded gardens and turned the city streets to mud. Jane Harden and her children huddled together in the blackness of noon in fear of the howling winds that shuddered the walls protecting them.

The hurricane bore down upon Savannah, uprooting trees and demolishing houses and wharves along the waterfront. Many of the storehouses erected at the foot of the bluff on what is now River Street were either completely destroyed or so badly damaged that their contents were a total loss. The river rose, covering all of Hutchinson Island, ruining most of the city's rice plantations and drowning over a hundred slaves. Eighteen of the vessels in the river harbor were heaved upon the wharves by the forces of wind and water. Twenty-four houses collapsed, many trees came crashing down and a number of persons lost their lives from flying bricks and falling timbers—including two of Nathanael Greene's children. The Mercantile Exchange, the filature, the courthouse, the jail atop the bluff and twenty-six businesses all sustained damage. Before the horrendous storm ended, the stocks were swept away and the steeple on the Presbyterian church (then at the southwest corner of Whitaker and President Streets) toppled, crushing a house and very nearly killing an invalid man inside.

Long after it was over, the lowlands lay inundated with stagnant water, providing ample breeding grounds for *Aedes aegypti*, yellow fever's carrier mosquito, against which an effective vaccine would not be found for another hundred years.

Until late autumn of 1804, the disease continued to claim lives. Jane Harden survived the hurricane but not the "bilious fever" that destroyed her

liver and kidneys, jaundiced her skin, dehydrated her body through vomiting and caused her to bleed from the nose and eyes. In a terrible coincidence, she died on Edward's birthday, September 27, just as he had died on hers. Her orphaned children remained in the care of faithful family slaves.

But the Harden legacy did not end there. Three generations later, Jane and Edward's great-grandson William Harden, an avid historian and former general in the Confederate army, became actively involved in the establishment of the Georgia Historical Society for which he served as librarian for many years. A rich trove of Savannah history is preserved in his several books and in the *Georgia Historical Quarterly*, of which he was editor.

The second owner of Edward Harden's four cottages was John Barnard (1750–1819), a wealthy planter with extensive property in Bryan and Chatham Counties. Like Edward Harden, Barnard earned the rank of major during the American Revolution. Under his command, his company once attacked the crew of a British frigate that had landed on Wilmington Island, where Barnard owned substantial holdings. During the bloody battle that ensued, he was taken prisoner. Perhaps because of his family's wealth and influence, his release was eventually arranged, and he was able to rejoin his company and continued to serve his country with honor until the end of the Revolutionary War in 1783.

Having received a crown grant of one hundred acres on Wilmington Island, he maintained a large and profitable rice plantation. By 1784 he had increased his holdings to include much of Wilmington and part of Little Tybee Island to the east.

As Barnard's plantation expanded, so did his family. He and his wife, Lucy Turner, raised seven children—Mary, Henrietta, Timothy, John, James, Lucy and Georgia. Such large families were commonplace in 1800, not only due to lack of effective contraception but also as an intentional hedge against high infant mortality. Not until 1880 would both conditions improve enough to reduce the average number of children per family to four.

Until John Barnard's death and burial in Laurel Grove Cemetery in 1819, he enjoyed many grandchildren, who grew up in privileged circumstances on the family's Wilmington Island compound. His children inherited their father's vast estate, which included a town "lot adjoining Mrs. Almy." The "lot" (including Harden cottage) went to his son-in-law, Stephen S. Williams, husband of John Barnard's daughter, Henrietta.

In turn, Stephen Williams left the cottage to his daughter Lucy. But since by law a husband assumed ownership of his wife's property, Lucy's lands,

Barnard Family

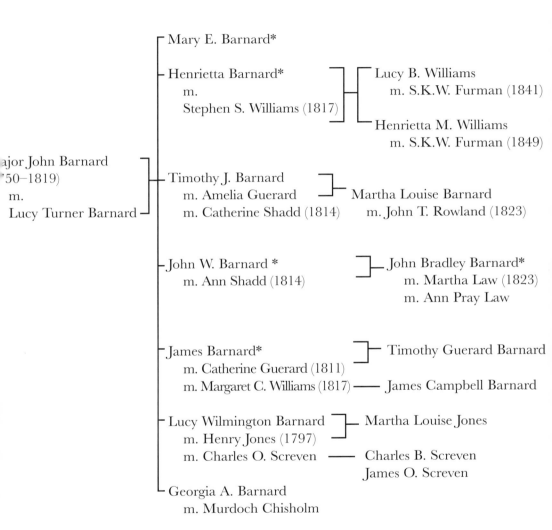

Major John Barnard
(1750–1819)
m.
Lucy Turner Barnard

- Mary E. Barnard*

- Henrietta Barnard*
 m.
 Stephen S. Williams (1817)
 - Lucy B. Williams
 m. S.K.W. Furman (1841)
 - Henrietta M. Williams
 m. S.K.W. Furman (1849)

- Timothy J. Barnard
 m. Amelia Guerard
 m. Catherine Shadd (1814)
 - Martha Louise Barnard
 m. John T. Rowland (1823)

- John W. Barnard *
 m. Ann Shadd (1814)
 - John Bradley Barnard*
 m. Martha Law (1823)
 m. Ann Pray Law

- James Barnard*
 m. Catherine Guerard (1811)
 m. Margaret C. Williams (1817)
 - Timothy Guerard Barnard
 - James Campbell Barnard

- Lucy Wilmington Barnard
 m. Henry Jones (1797)
 m. Charles O. Screven
 - Martha Louise Jones
 - Charles B. Screven
 James O. Screven

- Georgia A. Barnard
 m. Murdoch Chisholm

*Beneficiaries of John Barnard's will

forty slaves and cottage, subject to ground rents,[2] transferred to Samuel K.W. Furman (born 1819) when they married on March 2, 1841.

Samuel and his nineteen-year-old bride never occupied the little house at 503 East Saint Julian Street. They settled instead in Camden County, Georgia, where Dr. Furman had an established medical practice.

However, his practice probably did not support his comfortable lifestyle, since rural doctors in the 1840s charged modestly for their services. The cost of a house call, for example, was calculated according to distance: in daytime, fifty cents per mile and at night, seventy-five cents per mile. A husband could expect to pay four dollars for his pregnant wife's labor and delivery, while to set a broken leg he might pay as much as ten dollars. Surgery, such as a hernia operation, could cost anywhere from twenty to one hundred dollars. These medical fees, established by the College of Physicians of Philadelphia, increased only slightly over the next twenty years.

More likely it was Furman's large Camden County rice plantation, worked by about seventy-five slaves, which enabled Lucy to enjoy the same affluent lifestyle that her wealthy father had provided.

To the newlyweds' delight, Lucy became pregnant immediately, and at age twenty she gave birth to her first child—a daughter—also called Lucy after her mother, her great-aunt and her maternal great-grandmother. The Furmans were truly blessed, for in the next five years three more children arrived—Samuel Jr., William and James.

But when baby James was less than a year old, Lucy—perhaps weakened by childbirth—fell gravely ill. Samuel, frantic with worry, tried his best to heal his young wife, administering the medicines available at the time— calomel, rhubarb, jalap, castor oil mixed with molasses—and purging, bleeding to expel poisons or applying mustard plasters.

In the end, none of these methods had any effect. His darling Lucy continued to waste away. She finally died in 1848, her twenty-sixth year, leaving behind four children, ages five, four, two and ten months.

Exhausted and distraught with grief, Samuel turned to Lucy's family, the Barnards, for help. To his rescue came his spinster sister-in-law Henrietta Mary, Lucy's elder by one year, who immediately set forth from Savannah, chaperoned by her maiden aunt, Mary Barnard.

Imagine her dressed in traveling costume—a cinch-waisted dress of black silk, a matching cabriolet bonnet and a small reticule for her handkerchief and fan. By her side is her mother's parting gift, a pale blue pagoda (parasol) to protect her delicate complexion against the brutal Georgia sun.

As her carriage traveled south through Bryan and Liberty Counties, she had many hours to contemplate the challenges before her. What sort of

living arrangements would Samuel have made for her? How could she best serve and comfort this man whom her sister had loved? And the children— would they accept her into their lives? Or would they forever resent her taking Lucy's place?

When she and Aunt Mary stopped for the night—perhaps at the home of friends, or possibly at a "station" where weary passengers could purchase a meal and a bed for the night—did she toss and turn, wondering if she had made a rash decision? In her dreams did she order the carriage driver to turn back? And all the next day as the horses plodded past the pine forests of McIntosh County and through the cotton fields of Glynn, did she feel overwhelmed by the task that lay before her? Or did she embrace the promise of a new home and family that she looked forward to making her own? Surely she knew, as the "fingerboard" pointed the way to Camden County, that this journey would change her life forever.

Quite likely for reasons of propriety, Samuel Furman married Henrietta the following year on January 25, 1849. Although she was never to have children of her own, she led a full and busy life as the wife of this prominent physician-planter and the mother of four stepchildren. By the time she was twenty-eight, she was managing a household of nine, including Samuel's fourteen-year-old nephew Scrimzeour from South Carolina, her own aging aunt Mary from Savannah, the children's twenty-three-year-old male tutor, A.M. McIwer, and Samuel's nineteen-year-old overseer, Jesse R. Dean.

Did love eventually come for Henrietta and Samuel? Or was caring and kindness enough to make their marriage work? We know only that they were still man and wife twenty-one years later when they sold Harden cottage in 1870 for $2,300.

The purchaser was Thomas B. Downing (1832–c.1898), one of 1.6 million immigrants to the United States who had fled Ireland's Great Potato Famine of the 1840s. But unlike many of his penniless, unemployed countrymen, Downing came to America armed with both ambition and skills as a carpenter. He gambled that Savannah's need to house its burgeoning population would provide him steady employment, and he set about building (literally and metaphorically) a new life for himself and his wife, Johanna, whom he married in February 1851, when he was nineteen.

The couple settled in the "Old Fort" district, named for Fort Halifax (later renamed Fort Prevost and Fort Wayne), which was built on the nearby river bluff in 1754. It was a working-class neighborhood of cramped tenement

houses and rutted dirt streets that often reeked of horse manure. Like most families, they lived in rented rooms with an outdoor privy and a single fireplace for heating and cooking.

Although Savannah's first manufactured gas plant had started up in 1850, gas street lamps were few in the city, and the position of lamplighter— servicing the lamps' globes and wicks, lighting them every evening and extinguishing them the following morning—was not yet the sought-after job it would one day become.

Taverns, on the other hand, were numerous. Although by law Negroes were forbidden to patronize them, the white laborers, who worked the docks and dug ditches and graves, gathered nightly to revel and fight. Thus, after sundown, the dirt streets of Washington Ward became rowdy, dark and dangerous.

But if living in such a neighborhood was difficult for Thomas and Johanna Downing, they had endured worse hardship in their homeland. At least in Savannah there was food on the table and the company of their own kind, for by 1851 Washington and Greene Wards teemed with Irish Catholics.

At the end of their first year of marriage, Johanna became pregnant and, in August 1853, gave birth to their son Thomas Jr.—the first child, they hoped, of many. Unhappily, this was not to be. The baby died of *trismus nascentium* (tetanus caused by umbilical infection) when he was only seven days old. The following year, Johanna, like so many others who lived in sultry climates under unsanitary conditions, fell ill with "inflammation of the lungs" (possibly tuberculosis) for which bleeding, purging and opium were thought to be cures. At age twenty-eight, she also died, and Thomas—dazed with grief—buried her beside their infant son in Laurel Grove Cemetery.

Thomas never remarried. Ten years after Johanna's death, he purchased the cottage at 503 East Saint Julian Street, where he lived from 1870 to 1872. By this time he had laid down his hammer and become a clerk and bookkeeper at a commercial house.

Ever loyal to his roots, he joined the Irish Union Society, of which he later served as secretary from 1874 to 1876. There he met and befriended John Murphy, a fellow immigrant and the society's first president. Downing sold Murphy the cottage on April 26, 1872, for $1,200 less than he paid for it just two years earlier.

Little is known about John Murphy (died circa 1886), except that he worked as a stationary engineer for the Atlantic & Gulf Railroad and, prior to his purchase of the cottage, lived in a boardinghouse on the east side of Washington Square between Congress and Saint Julian with his wife, Mary (O'Neil) and their two children.

By 1886 both John and Mary were dead, and the court made their minor children, Michael and Mary, wards of Joseph Sullivan, a neighbor and

family friend. Thus the children's inherited ownership of 503 East Saint Julian Street transferred to their guardian on November 15, 1886.

Joseph Sullivan (1820–1887) and his wife, Mary, emigrated from Kenmare, County Kerry, Ireland, around 1848 with their first two children, John and Margaret. Like many immigrant families, theirs was an extended one, including Joseph's seventy-five-year-old mother, Mary, and thirty-year-old fellow laborer Connelley Murphy, also of County Kerry, Ireland. By 1860 Joseph had risen to the position of clerk of a commercial house, and Mary had given birth to two more daughters, Ellen ("Nellie") and Mary.

In 1866 Joseph built a new home for his family at 14 Price Street—a two-story brick building that exists today. He leased the Saint Julian Street cottage to his son, John, a laborer, who lived there with his wife, Julia.

His obituary in the *Savannah Morning News* (April 6, 1887) described Joseph Sullivan as a "worthy citizen," who died of a "short illness." For the last ten years of his life, he had been employed as a clerk at the Southern Bank, where he was regarded as "an honest, kind-hearted gentleman, in whom the utmost confidence was placed by those who knew him."

His wife, Mary, remained a widow until her death in 1895, at which time her daughters, Mary and Nellie, deeded the cottage to William J. Flood (1869–1943) for $825 plus annual ground rent of $4.50.

William Flood and his wife, Hannah, had been married for eight years when they acquired 503 East Saint Julian Street and the adjacent property to the west, number 501. In 1901 they razed the most westerly of Edward Harden's four cottages and, breaking with the architectural tradition of the neighborhood, replaced it with a three-story frame Victorian house. This house still stands at the corner of Price and Saint Julian Streets next door to Harden Cottage.

Despite the fact that they produced five children—Aileen, Alma, Camille, Mary and William Jr.—William and Hannah's marriage was not a happy one. It's possible that the death of their twenty-one-year-old son in 1921 drove a wedge between them. Or perhaps Hannah found her husband intolerably grim and strait-laced, once he became an active member in the state association of the Catholic Total Abstinence Union. Whatever the reasons, the couple eventually separated.

William continued to live in the family home on Saint Julian Street and to attend Saint Patrick's Church. Hannah, on the other hand, moved to Savannah Beach, Tybee Island, where, until her death in 1932, she was

Flood Family

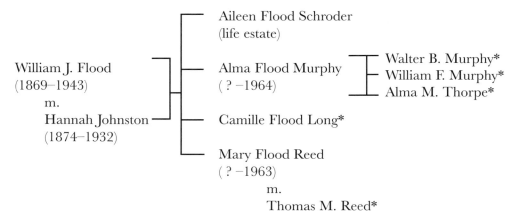

William J. Flood
(1869–1943)
m.
Hannah Johnston
(1874–1932)

Aileen Flood Schroder
(life estate)

Alma Flood Murphy
(? –1964)

Walter B. Murphy*
William F. Murphy*
Alma M. Thorpe*

Camille Flood Long*

Mary Flood Reed
(? –1963)
m.
Thomas M. Reed*

*Heirs of William J. Flood

an active supporter of Saint Michael's Mission. She is buried in Cathedral Cemetery, Caustin Bluff.

When her estranged husband died in 1943, his estate (including Harden Cottage) was divided among his daughter Camille, his deceased daughter Alma's three children, and Thomas Reed, widower of daughter Mary. His only other surviving child, Aileen Schroder, was granted a life estate, allowing her to live—widowed and alone—in the family home at 501 East Saint Julian Street for the next forty years. It is alleged that in her seventies she fell down the house's steep staircase and lay for several days, injured and unable to summon help. By the time her plight was discovered, the trauma had taken too large a toll, and she died in Candler Hospital.

Meanwhile, the little crooked house next door, now more than a century and a half old, had grown shabby and neglected and in the late 1950s was finally abandoned to the ravages of weather and time.

When its restorers bought it from the Flood estate in 1982, the roof leaked badly and vines snaked up through the heart pine floors. Derelicts and rodents had further degraded the property with their filth and debris. Rumors persisted that a petition was circulating to tear the eyesore down. After all, the 500 block of Saint Julian Street, now paved in tabby and flanked by elegant eighteenth-century homes, was quickly attaining the showcase status it currently enjoys.

But the story has a happy ending: fully restored the following year, the cottage was purchased by its present owners, who opened its doors to the public for the first time during the 1987 Christmas Tour of Homes.

No doubt Jane and Edward Harden would be pleased.

E. Bryan Street

Habersham Street

Warren Square

E. St. Julian Street

Price Street

E. Congress Street

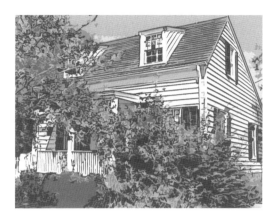

426 East Saint Julian Street
Warren Ward

At the corner of Price and Saint Julian Streets stands one of Savannah's prettiest clapboard cottages. Its colorful front garden, which showcases bright blooms that vary with the season, invites the admiration of all who pass by, while the walled garden in the back, shaded by a tall pear tree, offers cool respite from Savannah's summer heat.

Three small rooms, furnished tastefully with antiques, a modern kitchen and a bath occupy the downstairs, while the upstairs contains a second bath and a large, comfortable bedroom.

The cottage was built in 1845 by Henry F. Willink (1785–1873), a man of lusty appetites and firm opinions. Born in Hanover, Germany, he immigrated to Georgia, where he met and married his first wife, South Carolina native Lydia, promising that one day he would teach their sons his skills as a shipwright. But the family empire he dreamed of building

with Lydia was never realized, for she bore no children. In 1816 she died of yellow fever at twenty-four and was buried in Laurel Grove Cemetery.

Living alone held little appeal for Henry, a vigorous man who had grown accustomed to the comfort and convenience of a woman's presence. So four years after Lydia's death, Henry, now thirty-six, sought and won the heart of Jane Eigle, a Savannah native ten years his junior. They were married in 1820, and during the next four years Jane gave birth to Sarah Jane and Henry Jr. The Willink empire had begun.

Henry entered into partnership with John Wood, and both worked diligently as ship carpenters for the next several years. By 1827 Henry had earned enough to afford a new home for his family of four. He bought a lot at the corner of Habersham Street and South Broad (now Oglethorpe Avenue) and began constructing a large house that still stands today. And not a moment too soon, for by 1830 two more daughters, Ann S. and Emily Hermene, had joined the family.

Henry, ever determined and ambitious, eventually bought out his partner's half of Willink and Wood, and become sole proprietor of his own thriving carpentry business. Life was good.

For all of his admirable energy, Henry Willink emerges from between the lines of history as a gruff-natured man whom some people found difficult to befriend. He respected hard work and demonstrated little patience with anyone who wasted time—especially his. For example, because he demanded much of himself, he required the same effort from his slaves, dismissing the fact that for them life included almost none of the pleasures he enjoyed.

According to the code of 1755, all slaves were considered "chattel" in the hands of their owners and thus subject to many indignities. They were not allowed to read or write, purchase or sell alcohol, attend a parade, possess a dog or gun, or assemble—except for purposes of worship. Leaving an owner's premises without permission could result in a twenty-stroke lashing—Henry's preferred form of discipline.

Despite the threat of retribution, Willink's slaves often tried to escape a life of backbreaking work under their master's stern hand. Within a period of four years, a "Negro wench" named Daphne ran away; a mulatto boy, Edward, stowed away aboard an outbound ship; and Sam, one of Henry's best carpenters, tried to escape and was later sold.

In 1831 the tide of Henry's good fortune began to turn. Baby Emily died of fever in October. Five days later, the Willinks' eldest child Sarah Jane, ten, succumbed to "inflamed brain" (possibly meningitis). And just three months after that, in January 1832, Henry lost his wife Jane, thirty-four, to influenza—three burials in Laurel Grove Cemetery in four months. How much sorrow can one man bear?

Henry tried hard to operate his business while serving as both mother and father to his remaining eight-year-old son and three-year-old daughter, but it quickly became clear that he couldn't manage alone. So, ever the pragmatist, he focused on finding a third wife. Widow Isabella Hawkins proved a willing candidate, and just six months after Jane's death, they were married. If it began as a marriage of convenience, it must have developed into a deeper relationship, for Henry and Isabella's union lasted until her death forty years later.

Undaunted by his lack of education and driven to succeed at any cost, Henry was both admired and reviled by those whose lives he touched. As a result, some of the troubles that plagued him were of his own making.

For example, shortly before Christmas in 1833 while the Willink family lay sleeping, a stable at the rear of their house caught fire. The flames leapt from rooftop to rooftop, destroying every building on the block except the Willinks' home and separate kitchen before the fire was extinguished. Henry, who had no insurance on the property, lost over $3,000—a considerable sum for the times—and his neighbors lost even more.

The following day the *Georgian* contained a bitter letter from Henry expressing gratitude to the few friends who assisted him on the morning of the fire and adding that he was "not unmindful of those who took a flourish on the same morning around the ruins with laughter and scorn." Not long afterward he offered a ten-dollar reward for the prosecution of "person or persons who wantonly cut [his] gate in two."

His outspokenness and occasional scorn for the law only made matters worse. He apparently saw no connection between being fined four times for defaulting on jury duty and losing his bid to serve as city alderman. On top of all this, the death of Isabella's four-day-old daughter—her first child—from "infantine" made it a very bad year indeed.

But Henry persevered. By 1840 he had purchased wharf lot 19 in Trustees' Garden together with back lots 15, 16, 17 and 18 (now occupied by the Marriott Riverfront Hotel). This afforded him ample space to fulfill his dream of building his own shipyard, which he operated with the help of nineteen slaves. He also acquired other property in the thriving city of Savannah, including a lot at the corner of Price and McDonough Streets for which he paid "4 C[rowns] 120." There he built the clapboard cottage featured in this chapter.

By 1850 the Willink family included another daughter, Susan, and three more sons—Thomas, Joseph and Alexander. Years later when the thunderheads of war loomed on the horizon, all three boys signed up to support the Confederate cause.

Henry and Isabella's youngest, Thomas, was the first to enlist in the army. In May 1864, they learned that he had been killed in action.

Willink Family

Henry F. Willink
(1785–1873)
 m.
Lydia ?
(1792–1816)

 (No issue)

m.
Jane Eigel
(1795–1832)

- Sarah Jane
 (1821–1831)
- Henry F.
 (1824– ?)
- Ann S.
 (1829– ?)
- Emily Hermene
 (1830–1831)

m.
Isabella Hawkins
(1799–1872)

- daughter
 (1837–1837)
- Joseph D.
 (1835– ?)
- Susan E.
 (1839– ?)
- Alexander
 (1842–1866)
- Thomas M.
 (? –1864)

Son Joseph left his bride of one year, Carrie Haywood, to join the navy. One cold December morning in 1863, as the *Chatham* was steaming twelve miles from Sapelo Light bound for Nassau with a hold full of cotton and tobacco, the enemy attacked, firing "23 shells plus musketry." Joseph, along with his fellow shipmates, was taken prisoner and held for the duration of the war. After his release, he returned to Savannah and established himself as a locksmith with a store at the corner of Broughton and Drayton Streets.

His brother Alexander also joined the military, becoming a private in the First Regiment, Georgia Infantry. A year later he was transferred to the Sixty-third Regiment of the Georgia Infantry and eventually was promoted to Third Sergeant. Like his brother Joseph, Alexander was captured near Nashville, Tennessee, in December 1861, and sent to Camp Chase Prison in Ohio, where he remained for the next four years.

Alexander's story ended tragically. After the war, he joined the family shipbuilding business, working as a skilled machinist alongside his father and elder brother, Henry Jr. On a warm May morning in 1866, he volunteered to climb out on the end of a huge hoisting crane built on the wharf in order to repair some broken tackle. As both Henrys watched in horror, Alexander accidentally lost his grip and fell thirty feet to the wharf, breaking numerous bones and severely fracturing his skull. Workmen quickly fashioned a makeshift gurney and carried him to Henry Jr.'s nearby residence, where he lingered in agony for several hours before breathing his last. He was only twenty-four.

The fourth of Henry's sons, his namesake, opted not to serve in the military; instead he fulfilled a lengthy term as a shipwright's apprentice for another builder. Once he became proficient in his skills, he joined his father in business, quickly gaining the respect of the shipbuilding community.

In preparation for the War Between the States, the two Henrys built many famous warships—such as the iron-casemented ram *Savannah*, the *Macon* and the *Milledgeville*. One of Willink's ships, the CSS *Georgia*, holds an interesting place in Savannah's history, a story that began 145 years ago and continues to this day.

On March 9, 1862, the first two ironclad warships—the Union *Monitor* and the Confederate *Virginia*—engaged in fierce combat at Hampton Roads. By the time the famous battle ended in a draw, the superiority of ironclad ships had been proven, changing naval warfare forever.

Meanwhile, the women of Savannah, fierce supporters of the Confederate cause, had already begun to set "an example of patriotism and liberality… worthy of all imitation," according to the *Morning News*. When the first shot was fired at Fort Sumter, they began preparing bandages for the soldiers and making cannon cartridges of various calibers. They opened Wayside Home, dispensing food and lodging to more than 5,000 transient soldiers. They

1856 map of Savannah, showing location of Willink's shipyard. *Courtesy of the Georgia Historical Society.*

sewed 25,000 military garments for the Quartermaster Department, vowing to work until the last gun was fired, and they allegedly volunteered their silk petticoats to fund the construction of the first Confederate observation balloon used in battle.

So when the Battle of Hampton Roads established ironclads as the warships of the future, the women of Savannah rose to the challenge. They formed the Ladies' Gunboat Association and begin a fundraising drive. Summoning their various skills, they made and sold pincushions, baked pastries to sell at bazaars and formed knitting societies that produced socks and scarves. They arranged lectures and concerts with all fees going to their cause. Some even sold their jewelry. By 1861 they had accumulated an impressive $115,000—enough to underwrite the construction, at Willink's

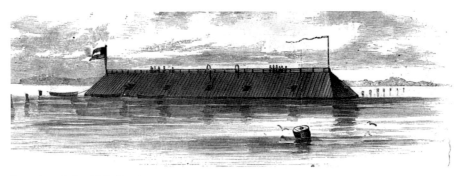

Drawing of the CSS *Georgia*.

shipyard, of the CSS *Georgia*, a 250-foot barge, roofed over and clad with 1,000 tons of railroad iron.

Georgia's first ironclad, known as the "Ladies' Gunboat," was launched May 19, 1862, and armed with ten heavy guns. Manned by a crew of twelve officers and eighty-two men, she served as a floating battery near Fort Jackson until December 1864. Then, realizing that Sherman's army was about to close in upon Savannah, the CSS *Georgia*'s captain issued the order to scuttle her to prevent capture by the enemy, and down she went like a stone.

Today a red buoy marks her grave at the bottom of the Savannah River, just three hundred yards from the fort she fought to protect. There she has lain, largely intact with all her armaments and stores, for 140 years—the only known Confederate ironclad still in existence. Whether she can be salvaged remains to be seen.

Another ship built in Henry Willink's yard was the 1863 Confederate steamer *Savannah*, an ironclad ram that carried two 7-inch and two 6.4-inch Brooke rifles. Her mission was to destroy the unarmored Union ships on blockade duty and then to assist the CSS *Atlanta* in a raid upon the enemy depot at Port Royal. Unfortunately, the Willinks were unable to complete the ship in time, forcing the commander of the *Atlanta* to proceed into battle alone. When she ran aground near Cabbage Island, the *Atlanta* became an easy target for the Federal ships *Weehawken* and *Nahant*, so to save the lives of his men, her commander surrendered his ship to the enemy.

Although not intended for battle, Henry Willink's very first ship, the pilot *J.R. Wilder* built in 1853, also made a significant contribution to the Confederate cause. Rendered useless as a piloteer by the closing of the Southern ports, she was deliberately burned and scuttled in the Savannah River channel to create an obstruction. Two years after the war ended, she was raised through the mechanical genius of Henry Jr., who, as a tribute to his father, painstakingly restored her to her former elegance.

Savannah's Little Crooked Houses

By the time Isabella Willink died in 1872 at age seventy-one, Henry Sr. had amassed a large estate, which at first he willed to his children and grandchildren, then later amended to name his German nephews as additional heirs. To complicate matters, he crossed out parts of the original will, acknowledging in the margin that he had done so. All this resulted in a nasty court battle that would rage for years following his death. Henry would have been outraged had he known how seriously the litigation would reduce the assets of his estate.

Ravaged by age, he was legally declared an "imbecile" at eighty-eight, just one month before he was laid to rest by the members of Solomon's Masonic Lodge. His fellow Masons formed a procession first to his residence and then to the family crypt at Laurel Grove Cemetery—an ignominious end to a long and industrious life.

The second owner of Henry Willink's cottage was William F. Dunn (1829–1899), an Irish immigrant who was nearly forty when Judge Levi S. Russell proclaimed him a citizen of the United States. Despite the fact that he could neither read nor write, William became a shopkeeper, a profession which must have provided well for his wife Anne and their four children—Nellie, Margaret, Annie and William Jr.—as over the years he was able to acquire numerous houses and lots within the city limits. One of these was the Willink cottage at the corner of Price and McDonough Streets for which Dunn paid $500 in 1868.

Like many fathers and sons, the two Williams found themselves at odds throughout William Jr.'s adolescence and adulthood. Apparently, the boy had no interest in the retail business and, in the eyes of his father, squandered his time non-productively. Their relationship became so strained that in 1899, when William Sr. drew up his will, he left seven houses in a life estate to his "beloved wife, Anne" and after her death to his three daughters. To his son, he bequeathed "ten dollars only" as he considered him "idle and improvident." Only if he mended his ways and became "an upright, industrious citizen and worthy son" would he share in the estate.

Anne Dunn, executrix of her husband's will (which he signed with an "X"), appointed her daughter Margaret as her successor after her death. According to the terms of their father's will, the three sisters were to judge when and whether their brother had sufficiently mended his lazy, wasteful ways. Apparently, William Jr. succeeded in turning his life around because ten years after his father's death, his sisters decreed that he should receive his portion of the inheritance.

426 East Saint Julian Street, Warren Ward

When Anne Dunn died in 1918, her daughter Annie Lacey (1870–1940) inherited the cottage and lot at the corner of Price and McDonough Streets, in which she and her husband, James Lacey, lived with their four children—Gertrude, William, Joseph and Annie Jr. Eventually, each child received an undivided one-fourth interest in the house under the terms of their mother's property settlement. In 1940 Gertrude (Mrs. James E. Rougham) and Annie Jr. (Mrs. Benjamin S. Wells) sold their portions to their brother William for $600 apiece.

In 1964, one hundred nineteen years after Henry Willink built his cottage at Price and McDonough Streets, the little house was moved to its present location at 426 East Saint Julian Street and purchased by Fred Wylly "Sonny" Clarke—realtor, competitive tennis player and son of a decorated Savannah war hero. He sold it to its present owner who has resided in the cottage since 1976.

E. Congress Street

Habersham Street

Columbia
Square

E. Congress Lane

Price Street

E. Broughton Street

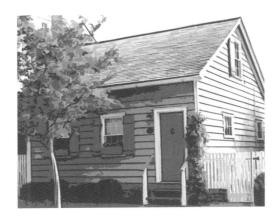

417 East Congress Street
Warren Ward

In 1791 when Warren Ward[3] was formed from the eastern common, an area used for grazing horses, the city deeded lot number 31 to Chatham Academy, which allowed it to remain unimproved for nearly fifty years.

Then in 1839, a free man of color, John Balon (variously identified as Ballon or Ballow or Barlow), leased the lot from the city for ten years with the understanding that any houses or other improvements he built on it would be his to sell if he did not renew. It is likely that the little crooked house on the northwest quarter of the lot—now known as 417 East Congress Street—was built by Balon the same year. For the next decade he lived in its three tiny rooms, which provided approximately nine hundred square feet of living space.

Balon was one of about five hundred free persons of color in Savannah, many of whom had arrived following the Haitian slave revolt in 1792. Despite their "free" designation, they were subjected to many of the same indignities

and controls as slaves. For example, a freeman (or freewoman) was required to pay one hundred dollars and to register within thirty days of arrival in the state, giving place of birth, former and present residences, purpose for coming and occupation. Failure to do so was punishable by a whipping, a fine or imprisonment. In addition, freemen were prohibited from owning real estate or slaves or engaging in any kind of business transaction. If they wished to hire out as tradesmen doing carpentry, tailoring, baking, butchering, blacksmithing or bricklaying, they were required to purchase a special badge for eight dollars and carry certificates of their freedom signed by their legally appointed guardians.

Acquiring a guardian was not easy. After the freeman named the white man of his choice, that person had to consent to serve, which required posting a bond (typically around $7,000) and petitioning the Court of Ordinary for Letters of Guardian. Once approved, the guardian—who received no compensation for his services—assumed responsibility for his ward, representing him in legal matters and making sure he renewed his annual registration. John Balon was fortunate to acquire Joseph Sullivan as his guardian, the man to whom in 1849 Chatham Academy sold the lot that Balon had leased for so long. Sullivan owned other properties as well, including the cottage at 503 East Saint Julian Street (see chapter one). Four years after purchasing the lot containing Balon's cottage, Sullivan sold it to Isaac D. LaRoche for $390. What became of John Balon is lost to history.

LaRoche (1818–1895) never occupied Balon's tiny cottage. He lived instead in a house on Orleans Square large enough to accommodate his wife, Georgia, eight daughters, three sons and some of their twelve slaves.

Although he worked at the Merchant and Planter's Bank at 78 Bryan Street, he also owned a brickyard, a profitable business in a city whose population already exceeded 22,000.

The need for bricks increased in 1834 when the city council mandated that all tenements (rental properties) of two or more units must have a partition wall of brick or stone at least eight inches thick.

An even greater demand for bricks occurred in 1839 when a city ordinance made it unlawful to build wooden structures between Gwinnett Street and the river and between East Broad and West Broad (now Martin Luther King Boulevard).

Furthermore, while most of the streets and lanes were mud and sand, a few were cobbled with either bricks or granite ships' ballast blocks to withstand the abuse of carriage wheels. Evidence of this early use of bricks can still be seen underlying the present surface of some of Savannah's modern streets.

Twenty-five million bricks were used to build the seven-foot-thick walls of Fort Pulaski on Cockspur Island, completed in 1847. Those used for arches and embrasures were imported from Virginia and Maryland, but the lower walls were constructed of larger-than-average, textured and porous "Savannah Gray" bricks.

Business was so good that the following year, Isaac built his wife, Georgia, her own brick three-story home at 210 West Harris Street—to this day one of Savannah's finest.

In addition to supplying brick for Savannah's builders, the LaRoche brickyard also sometimes doubled as a slave market. In February 1860, for instance, 140 frightened male and female slaves were led, one by one, to a platform erected in the center of the yard where they were paraded like livestock. How dehumanizing to have to display one's teeth, musculature and breeding capability for assessment, then to be sold to the highest bidder for an average price of $625. Perhaps their distress would have eased somewhat had they known that fourteen months later, on April 12, 1861, Henry S. Farley would fire a ten-inch mortar at Fort Sumter, initiating the war that would set them free.

In 1860, while hostilities were escalating between the North and the South, the tide of LaRoche's good fortune began to turn. His wife, Georgia, died of gastric fever and was laid to rest in Laurel Grove Cemetery. But Isaac didn't grieve for long. Within a matter of months, he found a new wife in the person of Josephine S. Adams, who agreed to assume the daunting task of managing Isaac's eleven children. Three years later Josephine also died, possibly due to complications from the birth of her namesake—Isaac's ninth daughter—in March 1864.

Not easily thwarted, Isaac set about finding a third wife to oversee his burgeoning household. For a prosperous man of forty-six with an elegant home and a flourishing business, he was a prime candidate for marriage—or so willing widow Maria A. Richards decided. They married just seven months after Josephine was laid to rest in Laurel Grove.

But Isaac's ill fortune persisted over the next four years. Two more children died: baby Josephine in 1867, and Maria's eleven-month-old son, Guy, in 1868.

Meanwhile the Civil War exacted a heavy toll on I.D. LaRoche and Company. Funds normally going toward new construction were diverted to the war effort, and after it ended, a terrible recession brought Savannah to its economic knees.

In order to vote and to conduct business in the city, Savannahians were required to swear before the First Provost Court that they had not been disenfranchised for supporting the war effort against the U.S. government. But even though Isaac took the oath of allegiance, his brickyard went bankrupt, and in his fifties he found himself starting over.

At first he operated a grocery and dry goods business with his son, Isaac Jr., but after only nine years, they sold out, believing they could make more money as auction and commission merchants. All sorts of merchandise changed hands at their offices at 168 Bay Street—a "very fast pacing horse," a basket phaeton and harness, a "safe and gentle" black mare, a "village cart," buggies—all "first class stock." According to an 1869 advertisement in the *Savannah Morning News*, Isaac D. LaRoche and Co. also dealt in real estate, bonds, stocks and items sold on consignment.

Yet LaRoche had not seen the last of misfortune. In 1873 he and Maria lost their four-year-old son Ralph (Isaac's fourteenth child), and in 1880, his eldest daughter, Alice, died, leaving her two minor children in Isaac's care.

Then on the night of December 9, 1882, a fire began on the second floor of the building he and his son used as a warehouse. Despite the efforts of four fire wagons and the combined help of citizens and firemen, about $5,000 worth of merchandise was destroyed.

A second fire broke out the following year at the same address, but this time firemen quickly extinguished the flames.

When Isaac died in 1895 at age seventy-seven, he was laid to rest beside his three wives and several children in lot 628 of Laurel Grove Cemetery.

The next owner and resident of the tiny house at 417 East Congress was Catherine Sullivan (1826–1906), formerly of Kerry, Ireland, and widow of John Sullivan, a policeman for the city of Savannah. Little is known about Catherine, except that she worked as a huckster (female merchant), maintaining an even tinier general store next door at number 415. The two structures shared a common wall and stoop, with the store occupying fewer than the nine hundred square feet of the cottage.

Catherine lived in her little crooked house until her death in 1906. Today it stands alone, the store having been torn down in the 1970s.

Her only heir, Catherine Palmer, occupied the little house for eight years with her husband James J. Palmer, a watchman at C. of G. Freight Warehouse. Although the Palmers sold it to Maxwell Gibbs for $800 in 1912, they continued to rent the property for two more years until they moved to 413½ Broughton Street.

Charles Maxwell Gibbs (1861–1948), who came from "fine old Southern stock," was born with the boom of Civil War guns echoing in his ears. After his graduation from Savannah High School, he spent three years at the Virginia

Military Institute and graduated in 1881 with the rank of captain. No doubt this pleased the young man's father, a war veteran who had been severely wounded fighting to defend Fort McAllister and later was captured by Sherman's troops as they marched into Savannah.

Charles found himself facing the decision all young men face—how best to invest the rest of his life. VMI offered him an assistant professorship, a prestigious position for a twenty-one-year-old, and Charles, who loved books and music, was tempted by academic life. On the other hand, his father was not well, and without Charles's help, Wilcox, Gibbs & Co., the family fertilizer business, might not survive. After much anguish and soul searching, he went to work for his father at 97 Bay Street and spent the next seven years learning the difference between "pure No. 1 Peruvian" and other types of "manipulated guano."

He also participated in the industrial and commercial advancement of the city by becoming an active member of the Ancient Landmark Lodge of Masons. He embraced the ideals of moral and social justice and brotherly love espoused by the Masons, and thus established himself as a respected member of the community.

But the private Charles Gibbs craved music and, in fact, demonstrated some talent as a composer. For example, he wrote "Georgia" and entered it in a competition to select a state song. When the judges narrowed the choices, Gibbs's song was among the final three, along with Savannah native Mollie Bernstein's "Anyplace is Home in Georgia." Ultimately, the honor went to Hoagy Carmichael, whose song "Georgia on My Mind" remains one of the nation's favorites.

After his father's death, Charles assumed sole proprietorship of the fertilizer company and became regarded as one of Savannah's foremost businessmen.

When he was twenty-six, he fell in love with Louisa Rowland, daughter of a prominent Savannah cotton warehouseman and shipper, and he courted her persistently until she agreed to become his wife. They married in 1888 and together produced one daughter, Rosa Williams Gibbs. The family lived in a handsome four-story townhouse at 9 East Gordon Street, keeping the cottage at 417 East Congress Street as one of several tenements purchased by Gibbs over time. It remained under his ownership for thirty-six years until a few months before his death. Charles Gibbs spent the last nine years of his life alone, his wife having died in 1939.

<center>❦</center>

By the time Marmaduke Hamilton Floyd (1888–1949) bought the cottage from Charles Gibbs in 1948, he had already spent four years at North Georgia Agricultural College and several more serving in World War I, after which he

returned to Savannah to assume the management of "Guerrard and Floyd," the family's cotton pickery. When his father died, Marmaduke formed his own cotton pickery, Floyd and Company, which he operated until 1939. By then he was also divorced from his first wife, Julia Heidt.[4]

Their daughter, Julia Frances—known as "Bonnie"—had established herself as an accomplished concert vocalist and served as choir director of Savannah's Independent Presbyterian Church. She ultimately earned her PhD at Florida State University and became a professor of history at Georgia Southern. Her brother, Marmaduke Jr., owned and operated a radio and TV repair shop in Savannah.

The second wife of M.H. Floyd Sr., whom he married in 1930, was Marie "Dolores" Boisfeuillet Colquitt, a dark-eyed Southern beauty with a keen intellect and an intensely inquisitive mind. Widow of William Neyle Colquitt, former clerk of the House Ways and Means Committee, Dolores was a woman of boundless energy. While raising two children—Adrian Boisfeuillet Colquitt and Mabelle Habersham Colquitt—she studied miniature painting at the Cocoran School of Art in Washington, D.C., and library science at Georgetown University. An avid writer and historian, she was one of the first persons to pioneer the restoration and renewal of the Georgetown (Washington, D.C.) area.

Following her wedding to Marmaduke Floyd, she moved to Savannah and served as assistant librarian in the city's public library system. Her special charge was the branch housed in Hodgson Hall, headquarters of the Georgia Historical Society, where she pursued her interests in Georgia history. The couple eventually built and occupied the elegant four-story masonry house that still stands at 116 East Oglethorpe.

In 1940 Marmaduke became superintendent of the Burnside Development Company, dealing in local real estate. During this time, he helped Dolores in the operation of a maritime museum, which she founded in the Pirates' House on East Broad Street.

Although not so prolific as his wife, Marmaduke did author several history-based articles, among them "Certain Tabby Ruins on the Georgia Coast." In the last years of his life, he worked as a contractor and land surveyor with an office at 20 East Broad Street. But at age sixty-one he suffered a heart attack and, shortly after his Roman Catholic baptism, he died at St. Joseph's Hospital. His grieving wife laid her husband to rest in a grove of live oaks in the Bonaventure annex of Laurel Grove Cemetery.

Dolores Floyd became a speaker and writer of local note, publishing many articles, including "Legend of Sir W. Raleigh at Savannah" in the *Georgia Historical Quarterly* and "Georgia Historical Society Has Reached Its Centennial" in the *Savannah Morning News*.

Determined to make a difference, she took on the Old Fort area, a terrible slum dominated by gas tanks, racial tension and the Irish poor. Her research on the

colonial Trustees' Garden was the nucleus of a restoration second to none in the country. Through her unflagging efforts, a number of historic buildings in the Old Fort area were saved—including several of the little crooked houses in this book.

Dolores, a widow for the second time, sold 417 East Congress Street in 1950 and went to live in Athens with her only child by her second marriage, Joseph Pierre "Picot" Boisfeuillet Floyd. Picot, who had earned a PhD in public administration at the University of Georgia, shared his mother's passion for history in general and Savannah's history in particular. After working as a staff writer for the *Savannah Morning News*, Picot became the first executive director of the Historic Savannah Foundation. During his tenure as city manager from 1966 to 1972, he was instrumental in acquiring grant funding for restoration of Savannah's dilapidated waterfront warehouses, a project that eventually became today's Rousakis Plaza and River Walk.[5]

His mother returned to Savannah for the last years of her life. When she died in 1966, she left behind a grateful city and an impressive body of written work in Savannah, Atlanta and Duke University libraries.

For a while the cottage's next owner, Bertha Friedman Goldin, and her husband, Simon, shared a residence on McDonough Street with his parents, Samuel and Lena Goldin. But after their daughter Doris was born, they moved elsewhere, eventually settling at 126 West Oglethorpe (now demolished).

The Goldins worshiped at Congregation Mickve Israel and had many friends among its membership. In 1934 when the old Levi Sheftall Cemetery (established in 1786 and located behind what is currently Savannah Station) became derelict through neglect, the board decided to rid themselves of the burden by deeding the property to Savannah. The board lobbied for the city to do the restoration, but the city would agree only to supplying equipment and materials. So members of the congregation, including Simon Goldin, took on the project. After months of arduous clearing of weed-choked plots, refurbishing of mossy old markers, pruning and replanting, the old burial site was finally reconditioned, and another bit of Savannah history was preserved.

In 1950, when Bertha Goldin paid $600 to Dolores Floyd for 417 East Congress Street, the 111-year-old cottage showed its age. Some of its clapboards had rotted, and its shutters hung askew. It was even more dilapidated fourteen years later when her daughter, Doris, sold it for only $10.

Since then John Balon's little crooked house has had several face-lifts and a variety of owners, all but one of whom are current Savannah residents. One recent owner who lived next door at number 419 for many years used the cottage as a guesthouse.

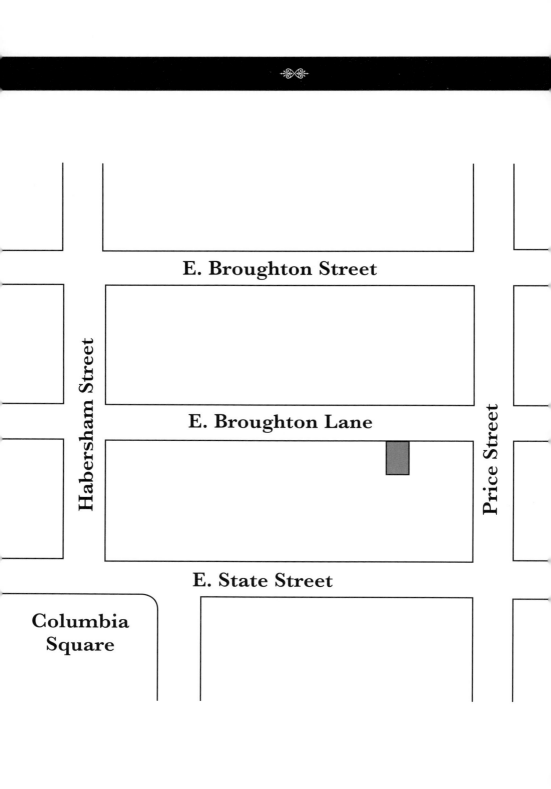

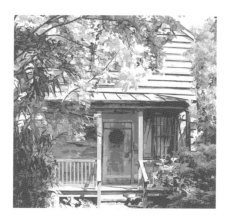

416 East State Street
Greene Ward

Tucked back into its narrow lot on State Street is the weathered wooden building known as "Laura's House," one of the oldest cottages in Savannah. Built prior to 1807 by Isaiah Davenport, the house originally stood at 122 Houston Street[6] facing Greene Square. In the custom of the times, its heart pine boards were pegged together, as can still be seen in the mantel of its central fireplace. Even today some of the interior doors retain their original indigo ("haint" blue) paint—thought to ward off evil spirits.

The cottage was built for Hannah Houstoun (1757–1793), wife of Dr. James Houstoun, who operated a dispensary in Savannah and, after the outbreak of the war, served as a surgeon in the hospital corps of the Continental army.

When Charleston was captured by the British in 1780, James was accused of treason and incarcerated in a common prison. Fortunately, his friend,

Savannah's Little Crooked Houses

James Wright, a governor of Georgia, heard of his plight and arranged for his removal to a private home, where he remained until the end of the war.

After his release, Houstoun returned to Savannah and immersed himself in the affairs of his growing city. Among other positions of influence, he served as one of five commissioners appointed by the state legislature to explore the feasibility of building a public market. The resulting structure at South Broad (Oglethorpe) and Barnard Streets served Savannah for decades until it was replaced by a new one at Ellis Square in 1827.

Dr. Houstoun's wife, Hannah, also played an active role in the community, serving on the board of the female asylum, an institution that supported children "under the patronage of the society."

The Houstouns enjoyed considerable wealth generated by their four plantations as well as other properties within the city—wealth that James planned to pass on to his two sons and two daughters after his death. Colerain, his 625-acre New Jersey plantation (including cattle, horses, timber, carts, carriages, buildings, forty-one slaves and crops of rice, potato, cotton worth £1,515) was to become the property of his elder son and namesake. In addition, James Jr. would receive 175-acre Argyle Island on the Savannah River, 30 acres on Hog Island and 25 acres "in the district of White Bluff."

Dr. Houstoun's younger son, Mossman, was slated to inherit Onslow Island on the Savannah River as well as his father's 370-acre plantation, Greenwich, thirty-five slaves worth £1,630 and miscellaneous livestock and buildings.

Each of his daughters would gain a lot in Savannah, a female slave and sufficient maintenance money to see to her comfort—the amount to be determined by the executors of his will.

Unfortunately, Dr. Houstoun's plans for providing for his children were thwarted when he died in 1793 prior to repaying his creditors nearly $78,000 that he had borrowed to improve his lands.

By the time his New Jersey and Georgia plantations were liquidated to satisfy the debt, his heirs realized little benefit from their legacies.

Hannah was not mentioned in her husband's will. However, despite his debts, she remained financially secure, owning a plantation on Skidaway Island, her cottage on Greene Square and twenty-two slaves whose value ranged from $20 to $400 apiece.

It is a mystery, then, why she neglected to pay the ground rent due on her little crooked house. A notice in the *Columbian Museum and Savannah Advertiser* warned that if $1.25 was not paid immediately, the property would be auctioned off on the courthouse steps in March 1807.

But Hannah, who was in residence at her Skidaway Island plantation, either ignored the warning or never learned of it. Shortly after she returned to her "town residence" in November, she fell ill with fever and died.

Two years later a judgment was brought against her estate, after which the sheriff sold the cottage for $1,105.87.

The purchaser was John Lawson (1774–1818) who, thirteen years earlier, had narrowly escaped death as a prisoner of war. Much to his distress, he found himself in chains aboard the British man-of-war *Defiance* in May 1796, awaiting the firing of a single gunshot and hoisting of a yellow flag that would signal the time for his execution. After witnesses from other ships were summoned and the articles of war read aloud, nine prisoners, including twenty-two-year-old John Lawson, were brought up on deck and fitted with nooses around their necks. What terrible thoughts must have tormented John during those sad final moments—never to see his parents again, never to marry, never to father a child…

Mere seconds before the hanging was to take place, Lawson and three others were given the news that a pardon had been granted them from His Majesty King George III. Freed from their nooses, one of the reprieved four, William Handy, immediately fainted, while John Lawson fell to his knees in gratitude.

According to the *Georgia Gazette*, he told the chaplain, "I am afraid I shall never again be so well prepared for eternity." He was then forced to watch in horror as one by one his fellow prisoners were hoisted to their deaths by a halyard, their bodies later sent ashore for burial.

His brush with death set the determined young man on a straight path to the future. He first established himself as a practicing attorney; then he began to search for a suitable young woman with whom to share his life. She turned out to be lively widow, Eliza Ferrar, from Liberty County, and the two married in December 1801.

John immediately immersed himself in the civic affairs of Savannah. He was appointed to superintend the aldermanic election for Franklin Ward and ran for alderman himself in 1804.

He served on a committee of three to oversee the education of children "schooled on the bounty of society," eventually becoming one of twelve managers of the Savannah Poor House.

He was also active on behalf of Chatham Academy and served as treasurer in 1810, the same year he sold Hannah Houstoun's cottage to Catherine Bourke for only $270.

By 1813, when Chatham Academy's newly built structure opened its doors to students, Lawson had been named one of the school's trustees. Among other duties, he served on the committee to establish rates of

tuition, which were thought quite reasonable considering the superior advantages of a private versus a public education. For twenty-four dollars per annum, students could learn reading, writing and arithmetic. English grammar and geography classes cost thirty-six dollars, while Greek and Latin required forty-eight dollars—payable a half-year in advance.

Two years later, acting as warden of Christ Church, Lawson announced an innovative plan—available for public scrutiny at his own home—to support the minister and to fund other church expenses by auctioning off all the pews on the ground floor in fee simple, subject to future assessments. The terms were to be liberal—a small portion in advance and extensive credit granted for the balance. Whether or not the plan was approved is unknown.

An educated man, John Lawson revered books. He once placed an ad in the paper requesting the return by the borrower of his second volume of Bacon's abridged *Law of England*, Dublin edition, printed in 1793. He also served as vice-president of the newly formed Library Society.

Whether by death or by choice, Eliza Lawson eventually exited the scene, and in 1812 John took Ann McQueen as his second wife. To her he left all his worldly goods when he died six years later of "peripamumery."

His sizeable estate included his first wife's dowry property in New Jersey, some real estate in Savannah, many slaves and personal effects.

Catherine Bourke, to whom John Lawson had sold the cottage in 1810, kept it for only three years. In 1813 she sold it for $92.52 to Isaiah Davenport, the man who had built it for Hannah Houstoun prior to 1807. Considering that this price was 92 percent less than the $1,106 paid for the cottage in 1809, one wonders—did the house deteriorate drastically in just one year? Or did a ruthless businessman take advantage of a woman in financial straits? The answer remains another of history's mysteries.

Little is recorded about Catherine's life except that she married John R. Odell in 1821 and died intestate in 1853.

Isaiah Davenport (1784–1827) was a colorful and important figure in the shaping of Savannah. He was born in Little Compton, Rhode Island, in 1784 and later moved to New Bedford, Connecticut, where he learned his skills as a carpenter. When he was twenty-three years old, he set sail from New York aboard the schooner *Undaunted*, arriving in Savannah on March 1, 1807.

Davenport Family

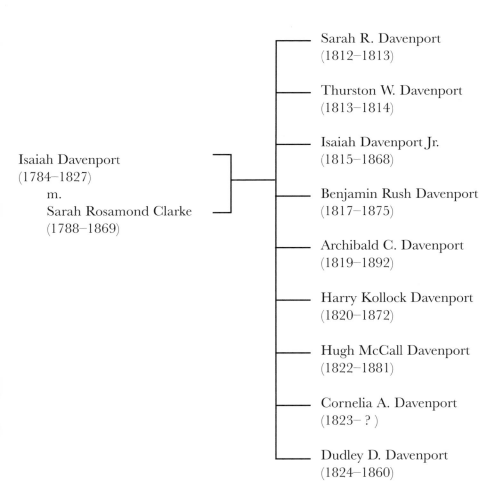

Isaiah Davenport
(1784–1827)
m.
Sarah Rosamond Clarke
(1788–1869)

Sarah R. Davenport
(1812–1813)

Thurston W. Davenport
(1813–1814)

Isaiah Davenport Jr.
(1815–1868)

Benjamin Rush Davenport
(1817–1875)

Archibald C. Davenport
(1819–1892)

Harry Kollock Davenport
(1820–1872)

Hugh McCall Davenport
(1822–1881)

Cornelia A. Davenport
(1823– ?)

Dudley D. Davenport
(1824–1860)

For two years Davenport courted Sarah R. Clarke, daughter of Susannah Clarke (see chapter seven). They married in 1809 and, over the next fifteen years, produced nine children.

His purchase in 1813 of the little crooked house he had built for Hannah Houstoun in Greene Ward was the first of many investment properties. By 1820 he was paying taxes on houses and lots in Washington and St. Gallie Wards as well.

He also constructed or improved many other buildings in and around Savannah—for example the Martello tower on Tybee Island—one of six wood and tabby structures erected by the U.S. government along the Atlantic coast as part of a defense system during the War of 1812. The tower fell into disrepair and was ordered destroyed just before WWI by the U.S. government, its place usurped by the bunkers of Fort Screven. Today only archaeological bits and pieces remain.

Isaiah also built Davenport House, a mansion on the northwest corner of Habersham and State Streets in 1821. Allowed to sink into dreadful dereliction over the centuries, this grand house now serves as Savannah's premiere museum and landmark. Its salvation sparked Savannah's restoration movement in the 1950s, an effort that continues to the present day.

Isaiah Davenport, a man of firm opinions, rarely hesitated to express his views. In February 1812, he joined fourteen other members of the Grand Jury in presenting a list of grievances, such as the practice of committing people to prison for "slight causes." According to the *Daily Georgian*, they also protested city lots that contained "filth and fermenting matter" and recommended that the owners be required to clean them up. Fearing that soil dug from cellars might contain matter that could threaten the public health, they recommended it be deposited outside the city limits, and they called attention to the terrible state of the public squares, which turned into muddy ponds whenever it rained. They noted the irresponsible and dangerous manner in which drays and wagons were driven through the city and labeled "as an evil of the greatest magnitude," the "tippling shops being kept open on the Sabbath day…leading to the commission of many acts of riot and indecorum."

Given his outspoken fervor for civic improvement, it's not surprising that Isaiah was elected to serve a term as alderman in 1818 and later was appointed to the board of health.

In 1821 he nearly lost his life in a terrifying encounter with Mother Nature. While he and Sarah were having tea at the home of their friend Mr. Raymond, a vicious storm struck the city. Mr. Raymond's house was struck by lightning, and both men were knocked unconscious and remained so for some time. The hair on the head of both was singed, and both sustained

scorch marks from head to foot. Isaiah, who was holding a child in his arms at the time, suffered torn skin and blistering on his chest and one leg. Oddly, although his shirt, vest, pantaloons and one stocking were singed, the child was unhurt.

The blast split the leg of the tea table, causing plates and cups to crash to the floor and badly frightening Sarah, who happened to be sitting there at the time. She wept with relief when both men regained consciousness.

For weeks afterward, the incident sparked much conversation among Savannahians who, then as now, delighted in gossip. Eventually, when Sarah moved into a house on Warren Square, the grapevine buzzed with rumors that the Davenports had divorced—or were at least estranged. However, no evidence of this exists.

Immediately following her husband's death during the yellow fever epidemic of 1827, Sarah put an ad in *The Georgian* offering for rent her house on Warren Square, "commodious" enough to suit a large family. She offered to vacate immediately.

But nine days after Isaiah's funeral, she changed her mind, proposing instead to open a boardinghouse for families and single gentlemen. She hoped to receive public patronage and invited her friends to help her make that happen.

By early November, Sarah had relocated to a smaller Davenport residence at the northeast corner of Barnard and Taylor Streets. She also leased the mansion on Columbia Square ("Davenport House") to Miss MacKenzie, a teacher who opened a school on the premises. The local paper noted that the teacher had reduced her rates as a result, charging only six dollars for orthography and reading, eight dollars for the addition of writing and arithmetic and ten dollars if history and rhetoric were included.

When Isaiah Davenport's estate was settled two years later, many of his properties—including the cottage on Greene Square—were sold at public auction to satisfy foreclosure of mortgages and other debts.

Sarah Davenport had been widowed for thirty-eight years when Savannah fell to Sherman's army in 1865. Like other Savannah residents, she was forced to endure for several months the terrible stench from carrion, offal and debris caused by about 75,000 men and hundreds of animals camped within or near the city limits. During February and March, the scavenger department, organized by the United States authorities, removed 568 dead animals, 8,311 cartloads of garbage and 7,219 loads of manure. Such "deleterious material" was blamed for the epidemic of sickness that swept the city immediately following the Civil War.

The Union soldiers, intoxicated by victory and full of bravado, entered residences at will and took whatever they fancied. Legend has it that when

the looters threatened Sarah Davenport's residence at the northeast corner of Barnard and Taylor Streets, she resisted, suffering the indignity of her invaders' jeers and laughter. Sarah, now in her late seventies, marched to General Sherman's headquarters (the Greene-Meldrim House at Bull and Harris Streets) where she declared emphatically to a guard that she wished to speak with General Sherman in person and would not leave until she did so. The guard refused her permission to enter and stated firmly that if she had a complaint, she must make it through one of the staff officers as the commander-in-chief was too important a person to attend to such trivial matters.

The controversy caught the attention of General Sherman, who demanded a reason for the disturbance. As described in William Harden's "Recollections of a Long and Satisfactory Life," Sarah

> told him, "General Sherman, I have a matter to lay before you and must talk to you in person."
>
> His reply was courteous. "Madam, I am a very busy man, but if you will not remain long, I will give you a few minutes of my time."
>
> He invited her in, and after seating herself, she said, "I have come to make complaint of the lawlessness of your soldiers and to ask for the protection of my property. I am the mother of six sons, three of whom are holding office in the Confederate States army and three serving the United States government in an official capacity."
>
> Before she could proceed any further, the general interrupted her, saying, "Madam, if there is any person in the city of Savannah deserving the protection you ask for, you are that person, and I will give instructions that a guard be placed at your residence and will see that you and yours are cared for as long as my troops remain in Savannah."

Satisfied, she thanked the general, turned on her heel, and walked out, her posture erect and her dignity very much intact.

Four years later in 1869, Sarah R. Davenport died in her sleep. She was eighty-one.

The next owner of the cottage on Greene Square was Samuel C. House (1799–1875), who purchased it at auction when the bank foreclosed against Isaiah Davenport's estate. Determined to improve himself, Samuel had completed a memory course and a course in English grammar by the time he was twenty-three.

His ambition may have been fueled by the desire to avoid becoming a grocer like his father, peddling such goods as coffee, rum, port wine, linseed oil, anvils, spikes, buck shot, chocolate, beef, ginger and claret wine at the family wholesale retail store on Jones wharf.

In 1822 Samuel successfully petitioned the legislature to become a notary public for Chatham County, and the following year he joined the Royal Arch Masons, who elected him "King" in 1826.

By the time he and his wife, Elizabeth, had four sons—John, George, Jefferson and David—Samuel had become secretary of Savannah Insurance and Trust company and a stockholder in the Central Railroad and Banking Company of Georgia. The family lived in a comfortable six-room house called Harrah, seven miles beyond the city limits.

During his residence in Savannah, House devoted himself to the betterment of the human condition. He served on the board of health for Greene Ward and as a member of the Savannah Bible Society. He was also active in the Savannah Benevolent Association, an organization established for receiving and disbursing relief during yellow fever quarantines.

By 1850 House had relocated to DeKalb County, where he lived until his death in 1875.

<div style="text-align:center">⁂</div>

The sixth owner of lot 18, Greene Ward, was Joseph Burke (1820–1865) from Brooklyn, New York, a commercial merchant and general exchange broker who had his own way of doing things—local ordinances be damned.

For example, in 1853 he allowed cotton bales to block the public lane behind his store at the corner of Bay and Abercorn Streets, a violation for which the city council fined him thirty dollars. He was further fined forty dollars for permitting four freemen to work for him without non-resident badges, a requirement mandated by the city council.

Burke did support Savannah's efforts toward civic improvement, serving on the board of health for Greene Ward and in 1863 helping to form the Importing and Exporting Company of the State of Georgia to encourage direct trade with foreign countries. His partner in the project was Marmaduke Floyd (see chapter three).

The same year that Joseph acquired the cottage on Greene Square, a fire damaged the roof of his residence, which was right next door. Fortunately for him—and for history—neither frame house was lost.

When his estate was probated in 1865, accounting records indicated he owned sixteen lots in Greene and Washington Wards, Prendergastville and Gilmerville, as well as property in New York.

Savannah's Little Crooked Houses

In 1869 his Georgia executor deeded the cottage on Greene Square to farmer Michael J. Hennessey (1829–1875) and to his brother-in-law Thomas Daniels for $3,300. Later that year, Hennessey bought out Daniels's share, becoming sole owner for the next fifty years.

❧❧

Although Thomas Daniels may have lived in the cottage's 734 square feet of space, Michael and his wife, Catherine, certainly did not, since they already had five children at the time of its purchase. Instead, it likely served Michael as a source of rent, which he was allowed to collect only after he, like all businessmen, took the oath of allegiance to the Union following the Civil War.

When Michael knew, at age forty-five, that he was dying of tuberculosis, Thomas Daniels accompanied him back to Ireland for a final goodbye. He died at Ballylanders, District of Gallally, Union of Mitcheltown, County of Limerick in 1875.

His will provided for his wife, Catherine; his daughter, Mary E. Colcolough of Charleston; his daughter-in-law, Delia Hennessey (widow of his son John T.); and two of his three grandchildren, Jeremiah P. and Marguerite Hennessey, both minors. To his third grandson, John Clement Hennessey, he left merely his gold watch and chain. The cottage on Greene Square was among the assets left to Catherine and the girls.

To put food on the table after her husband's death, Catherine Hennessey worked as a grocer and lived at 36 Houston Street (see chapter eight).

❧❧

In 1919 the cottage passed from Michael Hennessey's heirs into the hands of a realtor living in Savannah. He rented it to Laura Jones, a woman of color, appreciated for her year-round flower garden and window boxes full of beautiful blooms. Because she occupied the cottage for over fifty years, it became known as "Laura's house"—a term of affection still in use today.

Both Miss Laura and the house grew frail over the years, until the late 1960s, when the building was condemned by the city and slated for demolition. Fortunately, the Historic Savannah Foundation, recognizing its value, purchased the house and, with the financial assistance of Mrs. Frank Hollowbush, moved it to its present site at 416 East State Street—not an easy task. The house was so fragile with age that it had to be taken apart, board by board, and reassembled at its new location. Great care was taken to use the original bricks for the underpinnings and the fireplace.

Once moved, the house became the property of Beatrice Stroup, whose philanthropy and keen appreciation for history had already helped to change the face of the city.

<center>❧❦❧</center>

Born and raised in Philadelphia, Mrs. Stroup had the bearing and diction of a cultured English gentlewoman. She loved Savannah after visiting the city as a child and staying with her family at the old DeSoto Hotel (now demolished).

Both Beatrice and her husband, Donald F. Stroup, served in the military. She retired as an army captain after extensive duty abroad, and he retired as a navy man. After Donald's death, Mrs. Stroup purchased a mansion overlooking Monterrey Square, then spent several years restoring the house and furnishing it with exquisite mirrors, chandeliers, marble-topped tables and a writing desk at which John Greenleaf Whittier allegedly wrote his poetry.

When the opportunity arose to rescue Laura's House, by then 175 years old, Beatrice Stroup stepped forward, saying she felt duty-bound to preserve this little piece of history.

By 1972 she had transformed it into a tearoom where patrons could enjoy a relaxing hour with friends over coffee in the morning and tea in the afternoon. It offered an intimate atmosphere in a cozy setting with exposed ceiling beams and wide heart pine floors and wallboards pegged together in the custom of the day. To create the proper ambience, candle-like black iron wall sconces provided light while the old-fashioned cash drawer was kept hidden in a nook beneath the stairs. Guests sat comfortably at round wooden tables that had been hand polished to a satin finish. Each guest was served on an individual tray with white teapots from Williamsburg, strainers from England, and "butter chips" from France. For pennies one could enjoy scones, cucumber sandwiches, pound cake, hot gingerbread, johnnycakes or shoo-fly pie prepared in the kitchen.

Eventually, when teatime was eclipsed by cocktail hour, the tearoom closed and Laura's House reverted to a home coveted by a variety of renters. Currently owned by local residents, the cottage remains among one of the most highly regarded buildings in the National Historic District.

E. State Street

E. President Street

E. York Street

Greene
Square

Houston Street

E. Broad Street

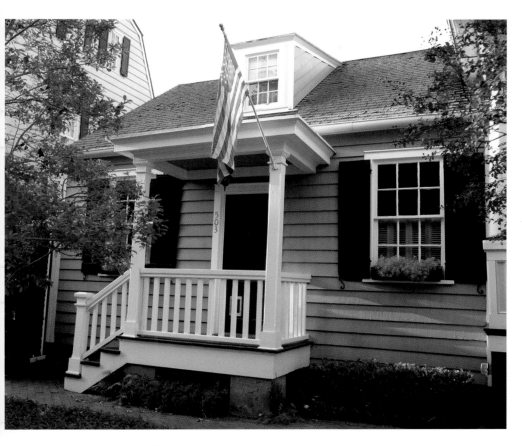

1. 503 East Saint Julian Street

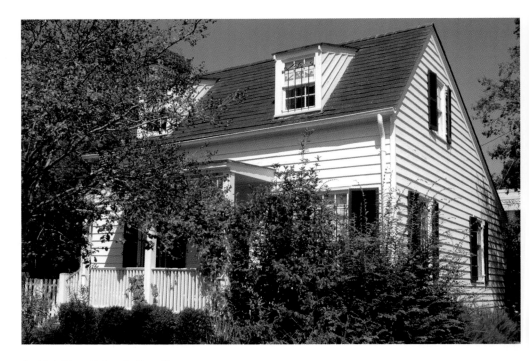

2. 426 East Saint Julian Street

3. 417 East Congress Street

4. 416 East State Street

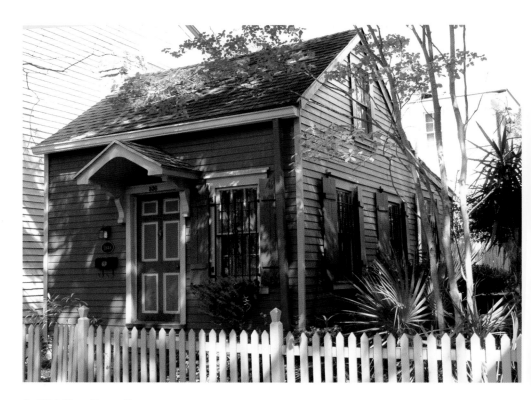

5. 536 East State Street

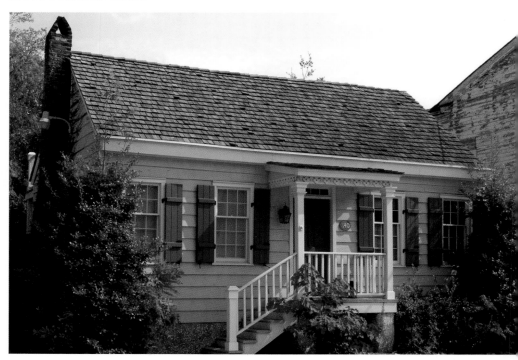

6. 140 Price Street

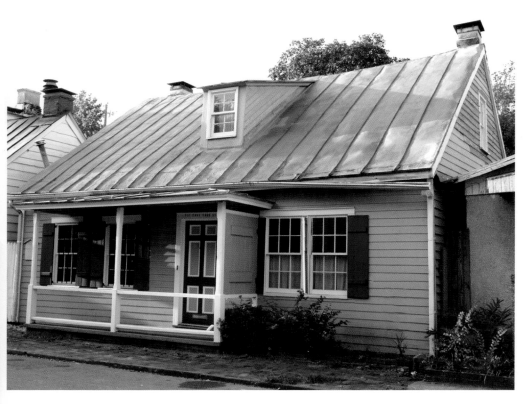

7. 517 East York Street

8. 519 East York Street

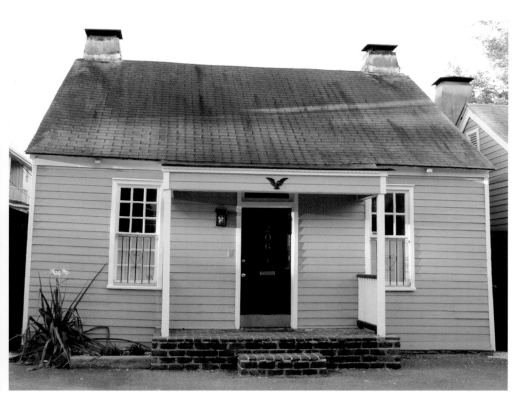

9.206 West Gordon Lane

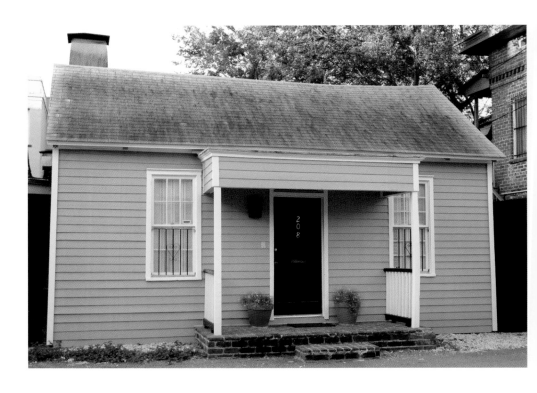

10. 208 West Gordon Lane

f i v e

536 East State Street
Greene Ward

During the middle 1800s, many a shipwright found ample employment in
Savannah's busy harbor. Among these was John W. Dorsett (1810–1898),
whose legacy lives on in a tiny barn-red cottage at 536 East State Street.

Dorsett was twenty-eight when he and Sarah Fletcher married in 1838.
During that same year he and Henry Sagurs purchased the entire stock of
Watts, Corwin and Dorsett and formed the firm of Sagurs and Dorsett,
Shipbuilders.

After working together for only six months, the two men dissolved their
partnership by mutual consent, and John continued on alone at "the old
stand" on the "lower and eastern wharf." There he built sailing ships, among
them a schooner whose fittings were fashioned on two forges in a forty-by-
twenty-foot building on the premises. His yard also serviced large ships, such
as the U.S. steamer *Beaufort*, which was hauled up for repairs in 1841.

But John Dorsett had even bigger ideas. One of them was to construct a marine railway that would work by horsepower with screw and rollers and would be capable of raising vessels of one to six hundred tons. He had the skills to build it; he had the crew to operate it. He needed only to acquire a certain ideal wharf lot on Hutchinson Island, and his dream could become reality. Unfortunately, the lot was sold to someone else, so John's railway plan was never implemented.

Like many couples dependent upon primitive medical care, John and Sarah Dorsett lost their first child, ten-month-old John Jr., to scarlet fever in 1842. However, two additional children—Fannie (born 1844) and Charles, (born 1846)—lived productively into old age.

When John was thirty-four, he hired his brother-in-law, master carpenter Dix Fletcher, to build Sarah a cottage with only 511 square feet of living space—the tiniest of Savannah's little crooked houses—at 422 Hull Street in Crawford Ward. The following year, just as the project reached completion, John fell ill with "dropsy" (painful swelling due to excess lymph, often caused by high blood pressure or heart disease). He died in October 1846, leaving Sarah to raise two-year-old Fannie and baby Charles on her own.

And so she did. Fannie, who never married, grew up to become a teacher at the Massie School and later principal of Girls' High School. She died in 1924 at age seventy, leaving her younger brother Charles an estate worth $3,000, including her half of the cottage on Hull Street that had been in the family for eighty years.

Charles also led a full, long life. At age nineteen, he felt honor-bound to join the Home Guard, Company A, artillery battery, which defended Savannah during Sherman's march through Georgia.

In the years following the Civil War, Charles married, fathered a child (Josephine) and began to establish himself as a real estate developer, forming a business that thrived over the next fifteen years. By the time he was thirty-nine, Charles was affluent enough to build a large two-story frame house at 215 West Gwinnett Street—still in existence—where the Dorsett family lived for the next half-century.

Charles Dorsett was a prominent and popular member of the Savannah community. He served for four years as county commissioner, participated actively in Wesley Monumental Church and held a life membership in Landrum Lodge of Masons.

He was eighty-five when the crash of the stock market and the Great Depression occurred—events that may have exacted a heavy toll on Charles's finances. In 1931, seven years after his sister's death, he defaulted on a $3,000 loan from his attorney, losing to her not only the exact amount he had inherited from Fannie but his mother's Hull Street cottage as well.

For the last several years of his life, the city paid Charles the honor of appointing him marshal of the annual Memorial Day parade. Older Savannahians can still picture this frail, white-haired old man with the bushy moustache riding in the leading automobile of the procession.

Charles died of cancer at ninety-three—one of the last two surviving members of Camp No. 756, United Confederate Veterans. To show its respect, the City of Savannah lowered the courthouse flag to half-staff and buried him in a casket draped with the Confederate flag.

The new owner of the Dorsett cottage was Charles Dorsett's lawyer, Anna Stowell Bassett, whose successful legal practice paralleled her husband's career in medicine.

Prior to assuming his new duties as Savannah's Commissioner of Health in 1923—an appointment he won by competitive examination—Dr. Victor Hugo Bassett (1871–1938) served under Savannah's chief health officer, Dr. William F. Brunner, remembered for maintaining the highest health standards for the city despite powerful opposition. Dr. Brunner's heroic insistence upon "rigid" quarantine during the yellow fever siege of 1888, over the vehement objections of the railroad industry and of local merchants, saved the lives of many Savannahians and earned him a place of honor in history.

His successor, Dr. Bassett, waged a similar war against disease in Chatham County, in particular against diphtheria, typhoid fever, tetanus and dysentery. He served as vice-president of the Georgia Public Health Association and as librarian of the Georgia Medical Society.

Dr. Bassett was a popular speaker. He once delivered a report on health issues in Savannah that not only attracted national attention but also earned him an invitation to the White House for a conference on child welfare.

In many ways he revolutionized the city's approach to healthcare. A believer in statistical research, he caused Savannah's vital records to be indexed, established a city diagnostic health laboratory, coordinated the public health nurses, established a midwife control ordinance and lobbied for hospital facilities to care for patients with tuberculosis and other communicable diseases.

After her husband's death at age sixty-seven, Anna Bassett closed her law practice and moved to Indiana to be near her only child, daughter Ellen Swenson, and in 1962, she sold the tiny house on Hull Street to a current Savannah resident.

Even though master carpenter Dix Fletcher had built the house well for the family that owned it continuously for 119 years, it revealed grim

evidence of its age by 1964. If not for the spirit of preservation alive in Savannah, the tiny structure might have been razed, especially since the city had other plans for the lot on which it stood (a parking area in front of the old city jail).

To the rescue came Stella Ihly Henderson, proprietor of the Colonial Lane Antique Shoppe, who (along with her husband, funeral director Lindsey P. Henderson) had been involved with patriotic, civic and cultural organizations and projects for over fifteen years. In 1941 she accepted the challenge issued by Dolores Floyd in the 1940s (see chapter three) to restore deteriorating buildings in the Old Fort area of Trustees' Garden. Ultimately, Dolores rescued twenty-nine houses in Washington and Greene Wards and received many national, state and local awards for her efforts.

Recognizing the unique charm and historic significance of the Dorsetts' little crooked house on Hull Street, Stella Henderson purchased it for $1,500 (plus $600 moving charges) and relocated it to its present State Street site overlooking Greene Square. For saving this and many other treasures, Savannah is ever in her debt.

E. York Street

E. York Lane

E. Oglethorpe Street

Price Street

Houston Street

140 Price Street
Greene Ward

This pretty cottage was built in 1828 for Frederick W. Heinemann (1794–1848), who emigrated from Germany at age three. The Heinemann family arrived in Charleston, South Carolina, in March 1797, but later that year they moved to Savannah, where Frederick's uncle, H.C. Heinemann, owned a store that sold men's clothing and brass-barreled pocket pistols. Frederick may even have apprenticed with his uncle, for he eventually became a successful commercial merchant and auctioneer.

When he was twenty-six, his sister, Phillipina, lost her husband—Savannah's postmaster Philip Box—and Frederick applied to the Court of Ordinary for guardianship of his nephew, Philip Jr. Little did he know that in Pennsylvania during the same year, an eight-year-old girl named Emma Neyle was entering Bethlehem Seminary, a boarding school established

by the Moravian Church. Twelve years later Frederick and Emma would meet, fall in love and eventually marry.

In the meantime, Heinemann became an active first sergeant and spokesman for the Savannah Volunteer Guard. His name appeared regularly in the *Georgian*, following announcements of such activities as parades, a gun salute to George Washington, the Independence Day celebration and the Oglethorpe Ball.

The year he was promoted to the rank of lieutenant—1829—he found himself facing arrest for a baffling federal crime involving counterfeit ten-dollar bills circulating throughout Georgia. The *Savannah Georgian* described the bills as "Plate D" with "clumsy" engraving and "muddy" ink on "indifferent" paper. Dated October 1, 1827, they were made payable to Frederick W. Heineman (*sic*) and endorsed by him to the bearer. By the time Frederick was able to convince the authorities that his signature had been forged, his reputation had been badly tarnished—frustrating to one who had worked honorably to serve his municipality.

Throughout the 1820s, Frederick began to acquire parcels of land available at sheriffs' sales for non-payment of taxes. Among them was lot 32, Greene Ward, where in 1828 he erected the first of four wooden structures—the cottage at 140 Price Street—that would occupy the site.

When Frederick was thirty-nine, he married Emma Neyle at Christ Episcopal Church, and in the following year, 1834, baby Elizabeth, the first of their six children, was born.

He took seriously his role as a parent, anticipating what he imagined as his children's future place in society. Perhaps influenced by his wife's educational advantages, he made sure his will emphasized his desire for his three daughters to receive "a liberal and accomplished education" in a seminary where their safety would be assured. It was important to him that his children dress in the manner of the majority of their classmates yet be provided with merely a small allowance. He expressed the wish that his only surviving son Henry receive as fine an education as financially feasible, preferably at Princeton, Yale or Harvard—provided, of course, that the boy had demonstrated intelligence and study habits equal to the challenge. After graduation, Frederick wished for Henry to seek distinction in the civil or military area of his choice. Apparently, a career as a musician, teacher or artist was unacceptable to this proud father.

In 1844, two weeks after giving birth to her sixth child and namesake, Emma Heinemann died of bronchitis and was buried beside her son William in "the old" (Bonaventure) Cemetery.

When her husband succumbed to "hemorrhage of the lungs" four years later, each of his orphaned children—ages ten, nine, six and four—inherited

Heinemann Family

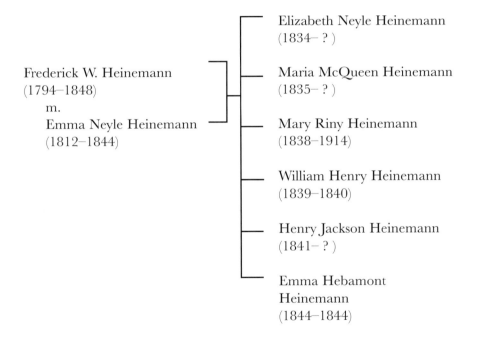

Frederick W. Heinemann
(1794–1848)
m.
Emma Neyle Heinemann
(1812–1844)

Elizabeth Neyle Heinemann
(1834– ?)

Maria McQueen Heinemann
(1835– ?)

Mary Riny Heinemann
(1838–1914)

William Henry Heinemann
(1839–1840)

Henry Jackson Heinemann
(1841– ?)

Emma Hebamont
Heinemann
(1844–1844)

four city lots and a share of the household furnishings. One of the properties left to his eldest, Elizabeth, was the cottage at 140 Price Street, which the administrator of her father's estate sold for her benefit in 1853 for $2,850.

<center>❧❧</center>

The new owner of Henry Heinemann's cottage was John Haupt (1780–1859), originally of St. Augustine, Florida.

Years earlier, sixteen-year-old John had been kneading bread at his father's side when fire broke out in the Haupt bakery near Savannah's public market. The great fire of 1796 quickly swept across the city, destroying hundreds of buildings and causing damages of more than $300,000. Three years later John Haupt's name appeared in the *Columbian Museum and Savannah Advertiser* as one of the victims who "could not or would not relinquish their right" to their share of "the donations to the sufferers." In John's case, that share amounted to $49.31.

Ironically, he forfeited almost that same amount in 1802 when he incurred double fines—one for dispensing liquor without a license and a second for selling to Negroes. He married Rebecca Lavender the same year.

Haupt had ongoing tax problems. In February 1807, the *Columbian Museum and Savannah Advertiser* listed his house at "5 Reynolds Ward" as one of the properties slated for sale due to delinquent taxes. He owed four dollars. The same notice appeared twice more in February and a fourth time in March, suggesting that the debt was not merely an oversight but one he could not afford to pay. Three years later he again defaulted on his taxes. This dubious record did not deter him from offering himself as a candidate for Receiver of Tax Returns for 1811.

After serving as secretary of Fire Engine Company No. 1 in 1810, John later became clerk of the city council, no doubt bringing issues of the former to the attention of the latter.

During his tenure, the council began to take a tough stand on fire prevention, reminding the public that Section 10 of the Fire Ordinance required all houses within the city limits to be equipped, at the owner's expense, with at least five buckets. Any owner of a wooden house who failed to provide a "sufficient ladder" or other access to the roof large enough to provide convenient access for an adult male would be fined up to thirty dollars.

The council directed fire engine managers to survey each home, ward by ward, and to report anyone not adhering to the city ordinance. Such measures proved of little use, however, when on January 11, 1820, Savannah's 7,523 residents experienced a horrendous fire that destroyed over 460 houses and cost $4 million.

When Rebecca Haupt died of "abscess of lungs" (perhaps cancer) in 1827, she left behind her husband and their seven children. His second wife, South Carolina native Eliza, helped shoulder the burden and added three more children to the family.

Even in his seventies, Haupt remained vigorous and involved. At age seventy-two he sought and was elected to his old post of clerk and treasurer of the Savannah Fire Company. When he was seventy-three, he squared off with the city council over the matter of a wooden platform that he built extending over the sidewalk on Drayton Street. He was warned that if he did not remove it in ten days, he would be fined fifty dollars for every day that the platform remained in place. Although disgruntled, Haupt complied.

Three years later he again found himself at odds with the city council, which commanded him to remove within twenty days a building on President Street. If Haupt did not comply, the city marshall was instructed to tear the building down. The outcome of the skirmish is unrecorded.

By 1854—the year he buried his son, Oliver—John had established himself financially. He owned stock in the Central Railroad and Banking Company of Georgia, a number of capital stocks, some slaves and various lots and large tracts of land in Effingham and Chatham Counties. When he died three years later at age seventy-nine, he was able to leave his family well provided for. To his wife, Eliza, he left the income on forty shares of railroad stock, two lots, the furniture and the silver. Each of his children received a specific lot (140 Price Street went to daughter Eliza Haupt Seyle) and an equal portion of the remaining assets, including his house slave, Edman.

The children's inheritance from their mother was much more modest—a "silver ladle and one quilt" to a daughter, a "mahogany bedstead and wool mattress" to a son, and so forth.

Eliza Seyle owned the cottage at 140 Price Street until her death in 1870, when her brother James, trustee for her minor children, sold it to Patrick Tuberdy for $6,500. However, Patrick didn't keep it long. Because of financial troubles, Tuberdy had to sell it a month later to his brother-in-law at a considerable loss—$2,500.

<div style="text-align:center">⋙⋘</div>

Life did not turn out for Patrick Tuberdy (1834–1900) the way he had planned when he and Catherine Daly married in 1866. For one thing, the youngest of their four children, thirteen-month-old Catherine, died in 1873. The following year Patrick's grocery and fruit business floundered, necessitating sale of the entire stock at cost. On December 31 of that year,

his wife fell ill and died. Three devastating blows in two years—how much can one man endure?

Having no wife, no job and three children to support, Patrick turned to Catherine's family, the Dalys, who had established themselves as boot-, shoe- and saddle-makers. For six years he peddled shoes and boots for the Dalys, learning the business so well that when Catherine's father Michael Daly died in 1879, Patrick opened his own store, Tuberdy's Boots and Shoes at 136 Broughton Street.

With the Civil War fifteen years in the past and the local economy steadily improving, Tuberdy found Savannahians eager and able to frequent his store. Before long he expanded his business by gaining a contract to supply shoes for the jail and convict camp. He was, finally, a man on the rise.

But operating a successful business was not without its problems. For example, one evening in 1892, a young man named Ed Doyle entered Tuberdy's store and placed an order for a pair of shoes. The order, signed by a J. McGinley, looked legitimate, so Patrick allowed Doyle to select the shoes he wanted and leave with the package under his arm.

Doyle went down the street to Simon Mitchell's clothing store and presented a similar order, signed by an Edward Moran, for a suit of clothes. But something about the order aroused Mr. Mitchell's suspicions, and he decided to stall Doyle until a policeman could be summoned.

Realizing he was under suspicion, Doyle dashed from the store and disappeared, leaving an angry Patrick Tuberdy to absorb his loss.

Another problem occurred in summer when yellow fever plagued the coastal counties, and those who could afford to do so fled the city, taking their custom elsewhere. Those who couldn't leave burned choking fires of wood tar in the squares, hoping to avoid the unknown cause of the disease. During one epidemic, all of Savannah's abundant "Pride of India" chinaberry trees, suspected of spreading the sickness, were cut down—yet still the fever raged. At such times, Tuberdy and eight other boot-and-shoe merchants were forced to close their stores from June 1 to September 1, Saturdays excepted.

Patrick was an Irishman with a good heart. He supported the Association of Robert Emmet (Irish orator and patriot) by serving as the group's vice-president in 1878.

And while so many of his countrymen compromised their lives with drink, he served as treasurer of the Father Mathew Young Man's TAB Society of Savannah, an organization devoted to preventing "the evils of intemperance." He was also a generous contributor to the fund for the relief of yellow fever sufferers.

When he died at age sixty-six, he left all his worldly goods to Mary Obrien, daughter of his friend and executor, Charles A. Obrien. Imagine her dismay

at receiving 535 pairs of men's shoes, 464 pairs of ladies shoes, 157 pairs of children's shoes, 300 bottles of tan polish and 51 bottles of black polish.

⚜

Few facts are known about James L. Morrissey (1820–1880), who bought 140 Price Street from Patrick Tuberdy in 1870 for a mere $2,500. Not only were the two men sons of Ireland, but they were brothers-in-law as well, as Morrissey's wife, Bridget, was Tuberdy's sister.

Seventeen years younger than her husband, Bridget produced five sons and two daughters, a large family for James to support on his policeman's salary, and times were often hard. In 1876, for example, the Georgia Mutual Loan Association foreclosed on one of James's loans at the same time the People's Mutual Loan Association foreclosed on another.

In spite of the Morrisseys' uncertain finances, the little house on Price Street remained in the family until ten years after James's death. He died at home, well respected by the public he served, leaving forty-three-year-old Bridget and their many children to struggle along without him. When Bridget died the following year, she was buried next to her husband in Catholic Cemetery.

In 1890 the Morrissey heirs sold the cottage at 140 Price Street to Diedrich Oetjens for $2,500—the same amount James had paid for it twenty years earlier.

⚜

Originally from Germany, Oetjens was admitted to citizenship in 1882—three years after he married Fredericka "Freddie" Dryer of New York. The couple had three daughters—Annie, Josephine and Mamie—and a son Diedrich Jr., who died in childhood.

Diedrich Sr. made his living as a grocer at 134 Price Street, next door to the little crooked house featured in this chapter. He sold the cottage in 1895 for $1,350, then died two years later, leaving Freddie the household furniture and some small promissory notes. He also left her the store with its contents of groceries, tools, paper bags, canned goods, glass, tinware, cheese, bottled beer, scales, coffee and tobacco—value $186.

⚜

The seventh owner of the cottage was Charles F. Shea (1870–1910), whose livelihood was plumbing but whose passion was baseball.

Savannah's Little Crooked Houses

In 1883 the Georgia Baseball League was organized at Macon by delegates from various clubs in the state. One of the six clubs was the Savannah Dixies, for whom Charles Shea played catcher.

On the first of sixteen road trips, Shea had two base hits, sending the Dixies to a 15–0 victory against the McCulloughs of Brunswick and setting a precedent that would continue throughout the season.

By September, after thirty-two season games, the Dixies found themselves battling for the state championship against the second Savannah team, the Oglethorpes. This caused such a local uproar on the day of the ninth game that after 3:00 p.m., trolley cars on the Whitaker Street line ran directly to the baseball park. Imagine Johanna Shea's excitement as she watched her husband's team win 16–9.

Later at the Pulaski House Award Ceremony, the league's president received some silk foul flags and a trophy—a handsome silver-mounted baseball bat. As he distributed less ostentatious trophies to each player on the winning team, word came that the *Florida Herald* Baseball Club of Jacksonville had issued a challenge: the team would arrive in Savannah on September 17, 1883, to take on the Dixies—providing their expenses were guaranteed in advance. Unfortunately, the outcome of this contest has been lost to history.

Did Charles Shea buy the cottage at 140 Price Street in 1895 to mollify his wife, a baseball widow? If so, she didn't have long to enjoy it, for Johanna died the following year.

Shortly before her husband died twelve years later, he sold the cottage to Dennis Shea (see chapter seven) for $1,300.

By this time, the Old Fort area, an Irish enclave, had fallen into decay—its houses worn and weary from too much use and too little maintenance. Dennis Shea was fortunate to find a buyer for his cottage in the person of Caroline ("Carrie") Cook (1884–1965), who paid $1,500 for it in 1910. But for Carrie it was merely an investment that she kept for three years, then sold, earning a slight profit.

Not much is known about Carrie Cook except that she lived a solitary life, never marrying, never having a family of her own. During her younger years she boarded with her sister, Elizabeth, and brother-in-law, Harry M. Wilson, probably earning her keep by sharing in the care of the Wilsons' three small children. Later she occupied various rented rooms in the vicinity of the Thirty-seventh Street School (now owned by Savannah College of Art and Design), where she taught for half a century. She died in 1965 at age seventy-two.

140 Price Street, Greene Ward

❧❧

The new owner, George Christodoulo (1878–1944) had emigrated from Greece in 1905. He worked as a confectioner at 138 Whitaker Street and lived at 503 East York, former residence of Diedrich Oetjens and his wife Fredericka. He bought the cottage at 140 Price Street in 1913 and one year later deeded it over to his wife, Mary—also a Greek immigrant—for ten dollars. When George died intestate in 1944, his funeral was held at St. Paul's Greek Orthodox Church. The modest estate was divided among his wife and three children.

When Mary Christodoulo died in 1991, her estate included the cottage on Price Street. Two of her grandchildren subsequently sold the house, which changed hands several times prior to its reconstruction in 1998.

Of the ten antebellum cottages included in these pages, 140 Price Street has undergone the most dramatic change in the 180 years of its existence. The eastern half of the building, originally a separate dwelling at 504 East York Lane, was completely gutted, leaving only the roof and a few structural members to serve as a framework for rebuilding. The old walls, windows, floors and clapboard siding were discarded and replaced.

Although the structural integrity of the Price Street house was maintained for the most part, much work was undertaken to modernize and open the interior. In the late 1990s, the two reconfigured cottages were joined, more than doubling the living space.

Greene Square

E. York Street

Price Street

E. York Lane

Houston Street

E. Oglethorpe Street

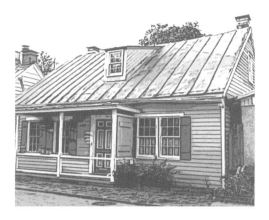

517 East York Street
Greene Ward

In Greene Ward, newly formed in 1806 from part of the east common, stand two side-by-side cottages that share a complex history. Except for the addition of plumbing, electricity and a couple of windows, the exterior of the older house, 517 East York Street, has remained essentially unchanged since it was erected in 1808—or maybe earlier.

It was built for Susannah R. Clarke (1761–1829), quite likely by her husband, Stephen B. Clarke, formerly a captain in the Revolutionary army and later a carpenter. He built it in a style typical of early cottage architecture with a central front-to-back hallway dividing the downstairs. On the east side is a small living room and kitchen, and on the west, two bedrooms and a bath. Each of the four main rooms was originally heated by a corner fireplace. The upper floor, once an attic, now contains the master bedroom and bath.

Today a modern skylight and two western windows augment the light from the original single dormers on the north and south.

Susannah had enjoyed her new home for only a year when her husband put away his tools one August day and boarded a boat, prepared to travel part way downriver in the company of a friend who was departing for the North. Did the oppressive summer heat overcome Stephen Clarke during the long, steamy afternoon on the water? Or did the two friends lift a few too many glasses of ale to toast the parting? Whatever the cause, upon his return to town that evening, Stephen lost his balance and fell into the swiftly moving Savannah River. Before help could be summoned, he was swept to his death by the strong current.

The following day, a group of his friends gathered on the wharf to discharge a cannon into the water in attempt to retrieve Stephen's body. After several attempts, the corpse did rise to the surface, and they managed to haul it to the riverbank. Stephen was buried the following morning with full Masonic and military honors. His obituary in the *Republican and Savannah Evening Ledger* described this New Jersey native as an "upright and benevolent man, a tender and affectionate husband, a sincere friend, and very generally esteemed in the community."

Susannah, shocked and grief-stricken, bore her sorrow alone, for her only child, Sarah, had become Mrs. Isaiah Davenport five months earlier (see chapter four). Although Susannah was only thirty-eight when Stephen died, she chose never to remarry but to live by herself in her little crooked house for the next thirty-three years.

After her death from "paulsey" in 1832, her daughter sold the cottage for $300.

<center>⁓⬥⁓</center>

History records little of the life of the new owner, John F.G. Davis, except that he worked for the State Bank of Georgia as a porter, a position that paid merely a dollar per day—paltry wages even in 1832. He also served as guardian of minors John and Valeria Davis on whose behalf in 1825 he sold "one Negro man named Tom" and "one Negro woman named Sander" to satisfy an execution of the court of common pleas. The following year his finances improved somewhat when he was appointed city constable representing Reynolds Ward. But in January 1833, John Davis's luck changed dramatically when his name was drawn in the gold lottery just six months after he purchased Susannah Clarke's cottage. The name of Henry F. Willink—already a wealthy man—was drawn as well (see chapter two).

Four years later Davis sold the cottage at 517 East York to Owen O'Rourke from Leitherin, Ireland. O'Rourke, who had leased the house for his own use since 1835, paid Davis $1,837 for it—500 percent more than Davis's purchase price just two years earlier.

Oddly, Davis died in a way similar to Stephen Clarke. According to a coroner's inquest, he fell into Lama's Canal around 10:00 p.m. on a cold December night in 1858 and was drowned. The death was ruled an accident.

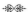

The cottage's new owner, Owen O'Rourke (1786–1864), was the head of a large Irish Catholic household, including three daughters, two sons, his fifty-one-year-old father and sixteen slaves. The family lived around the corner at 24 Houston Street (now demolished), between York Street and York Lane. On the southwest corner of York and Houston was a small, one-story frame building, and next door to the west stood the two cottages at 519 and 517 East York Street. At one time or another, O'Rourke owned all four properties.

A skilled stonemason by trade, O'Rourke was employed by the City of Savannah in 1844 as superintendent of streets and lanes, a challenging and physically demanding position for a man of fifty-eight. For the next nine years he labored, earning a salary of $500 per annum. Eventually, however, ill health took its toll, forcing him to resign his city position and to seek a more sedentary career. In 1853 at age sixty-seven, he was elected to the position of director of the Chatham Mutual Loan Association.

Although he was a loyal Savannahian who volunteered for several terms on the board of health, Owen O'Rourke was first and forever a son of Ireland. In the company of his Irish brethren, he tended to indulge himself in sentimental blarney. In March 1841, a reporter for the *Georgian* described a meeting of the Hibernian Society at the City Hotel, which "was passed in a most delightful manner with wit, sentiment, and song." At one point in the evening, Owen O'Rourke lifted his glass and delivered the following toast: "To the shamrock—a true emblem of the valor, wit, and beauty of my native land. Long may it sparkle with the waters of friendship as it gushes from the bountiful fountain of hospitality."

Eventually, the large O'Rourke family shrank to three. Mrs. O'Rourke disappeared from public records shortly after the birth of James in 1838, and ten-year-old Owen Jr. died from convulsions in 1848. Eldest daughter, Elizabeth, married George T. Theus in 1850 and started her own family. The following year her younger sister, Anna, married Captain Charles

O'Rourke-Theus Family

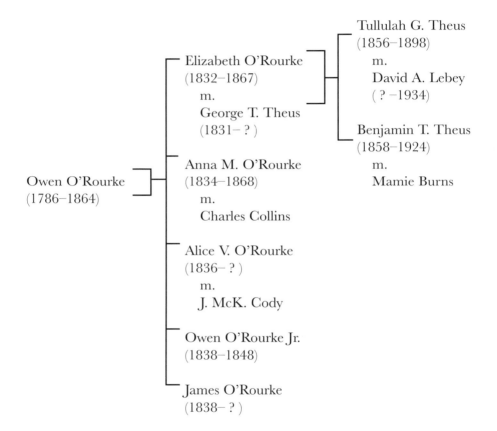

Owen O'Rourke
(1786–1864)

Elizabeth O'Rourke
(1832–1867)
m.
George T. Theus
(1831– ?)

Tullulah G. Theus
(1856–1898)
m.
David A. Lebey
(? –1934)

Benjamin T. Theus
(1858–1924)
m.
Mamie Burns

Anna M. O'Rourke
(1834–1868)
m.
Charles Collins

Alice V. O'Rourke
(1836– ?)
m.
J. McK. Cody

Owen O'Rourke Jr.
(1838–1848)

James O'Rourke
(1838– ?)

Collins and moved to New York. Owen's youngest daughter, Alice Virginia, died in 1854. By 1860 James, too, was gone. Owen, now a sad old man of seventy-four, lived alone in the two-story house that had once resounded with laughter and activity.

In 1863 Owen became paralyzed—probably from a stroke—and could no longer manage on his own. With Anna living in New York, the obligation for his care fell upon daughter Elizabeth. She dutifully packed up her household and moved back to the house on Houston Street, bringing along her husband, George, and their two children, Tullulah,[7] age four, and Benjamin, age two. She and George cared for ailing Owen for the next two years.

Since most of the buildings in this part of the city were built of wood, the risk of fire was constant. On a warm May night in 1863, Elizabeth awakened in a room full of smoke. She roused George, who discovered flames enveloping the small, vacant shop of Daniel Finnegan, their neighborhood grocer on the corner of Houston and York. Elizabeth wrapped her sleepy children in blankets and rushed them outside, while George, after raising the alarm, struggled to evacuate Owen. They watched the flames climb higher and higher, fearful that sparks would ignite their house—or worse, the entire block. But thanks to the skill of the firemen, only the corner store was destroyed and the O'Rourke home escaped major damage. Both properties belonged to Owen, who, it turned out, was uninsured for the loss.

Years later, on the site of the ruined shop, a masonry building would be built to serve as a family grocery with living quarters on the second floor (see chapter eight). Today that building—now designated as 521 East York—is part of a contemporary private residence facing Houston Street. It occupies the site where the O'Rourke home once stood.

Seven years before his death, Owen created a will directing that his entire estate, including seven slaves, a few railroad stocks, household goods and the above-mentioned four city lots, was to be divided equally between his two surviving daughters, Anna Maria Collins and Elizabeth Theus. It stipulated that the women be "free from the control, management, or advice" of their present or future husbands—an enlightened idea in the mid-1800s—and were to be paid a "just and reasonable support from time to time." Although the original terms of the will prohibited sale of the property in order to preserve it for his daughters, O'Rourke later had second thoughts—perhaps realizing that war with the North was inevitable. He signed an amendment instructing his executor to sell all his slaves as soon as possible after his death. He also instructed that his real property be sold whenever it seemed prudent, and that the money be invested for the benefit of his daughters.

Savannah's Little Crooked Houses

Owen O'Rourke never lived in either of his little crooked houses on York Street, but continued to live around the corner at 24 Houston Street for the remainder of his days. He died at age eighty in October 1864, and was buried in Catholic Cemetery.

<center>⚜</center>

Two years later the cottage at 517 East York Street was purchased for $1,225 by John Bartow Howell (1817–1873), who was a magnet for misfortune.

His troubles began in 1852 when, within a few months, he and his wife Susan Margaret (Timmons) lost their three-year-old daughter, Armenia, to typhoid pneumonia and John's mother, Sarah, to "dropsy of the chest" (edema often caused by kidney or heart disease).

In 1854 a combination of atmospheric conditions occurred that almost guaranteed an outbreak of the dreaded "bilious fever"—a mild winter, an early spring, enough rainfall to fill the surrounding swamps and low grounds with stagnant water and, finally, an intensely hot and oppressive July. To make matters worse, the city's primitive sanitation methods permitted trash and waste to be discarded in the streets and lanes, earning them the reputation of being among the filthiest thoroughfares in the South.

The resulting epidemic that began in August raged through the city until it peaked on September 12, a day on which fifty-one burials were reported. John Howell's wife, Susan Margaret, was among the dead.

Overwhelmed with the problems he faced in the immediate future, John barely had time to grieve. How was he to provide proper care for his two-year-old daughter, Claudia, and still maintain his grocery store at the corner of Jones and Drayton Streets? In desperation he may have turned to the family of his brother Richard Howell, an engraver, for temporary help. Soon, however, it became clear that more permanent arrangements must be made. With a heavy heart, he sent his only child to live with his wife's relatives in Rhode Island, a decision that would alter—perhaps even jeopardize—his life.

Determined to move forward, John built himself a handsome brick home at 24 East Jones Street, where he lived alone for the next twelve years. He involved himself in the affairs of the city, serving on the "fourth beat" of the Committee for Organizing the Arms-Bearing Residents as well as on the board of health for South Oglethorpe Ward. Always a staunch and outspoken advocate for civic improvement, he once became so outraged at the deplorable condition of Savannah's streets, some of which had formed permanent ponds, that at one board meeting he vehemently demanded instant action by the chairman of the committee on streets and lanes.

During these years, he traveled to Rhode Island as often as possible to monitor his daughter's progress. It must have pleased him to find that Claudia, at thirteen, had begun to blossom into the graceful, cultured woman she would one day become.

On one such visit he met Hannah S. Theron, an attractive widow who lived alone in a house she owned in Kingsville. She received him most agreeably and reciprocated his obvious attraction. Reminded of all the feminine comforts he had done without since the death of Susan Margaret, John began to court Hannah in earnest, and when in 1865 he asked her to be his wife, she happily agreed. She signed over her Rhode Island property to her intended husband and began preparing for the move to Savannah. They married the following August 1866, when Claudia was fourteen. It was a union forged in hell.

Perhaps it wasn't really love that brought them together, merely loneliness. Or maybe they each had lived as single people too long to adapt to the constant presence of another person. Without question they had different sexual expectations—and with reality came dismay.

John became so disenchanted with Hannah that after only five months he began to frequent a brothel. There he met Josephine Miller (alias Eliza), a lively, conniving wench with whom, to Hannah's mortification, he began an illicit and adulterous affair.

Deeply offended by her husband's rejection, Hannah suffered such an agony of humiliation that she could scarcely force herself to venture forth in the unfamiliar city where she had few, if any, friends. Her tears of protest would be dismissed with contempt by John, who ignored her pleas to abandon his flagrant philandering. That he preferred to bed Eliza Miller, a woman of such low breeding, instead of his own wife insulted every fiber of Hannah's being. Not only had she been duped into a loveless marriage but also into sacrificing both her dignity and her property.

One night during a terrible argument, John struck Hannah repeatedly, finally ordering her from his house. Outraged, she took immediate legal action. She testified that her husband had treated her cruelly, beating and abasing her, and she tearfully recounted John's adulterous behavior with the prostitute Eliza Miller during the course of her two-year marriage.

As a result of this action, in 1868 the judge ruled in her favor, requiring John to pay his estranged wife $500 per year as well as $150 in lawyers' fees.

After four more years of humiliation, Hannah had had enough. She sued for divorce—an action that, in itself, must have heightened her embarrassment. An 1850 statute defined grounds for divorce to include "adultery by either party after marriage" and further provided that in cases of abusive treatment, the jury could determine whether to grant

a total divorce or merely a divorce "from bed and board." Three days after Hannah's petition, a superior court jury, sympathetic to her plight, authorized the total dissolution of the marriage. In the settlement she received the "separate estate and house" in Kingsville, Rhode Island, that had been hers prior to the marriage as well as alimony, significant property in Savannah, and court costs. She left town on the next train heading north and never looked back.

But John Howell's experience with Hannah had not soured him on marriage. So besotted was he with his mistress that nine months later, at age fifty-five, he made Eliza Josephine Miller his wife. The new Mrs. Howell, a woman of limitless greed and ambition, immediately pressured him to make a will naming her a beneficiary, and he complied, bequeathing her a lot in Gaston Ward as well as the household furniture. To his daughter, Claudia, now twenty and still living in Rhode Island, John left the cottage at 517 East York Street, a second lot in Oglethorpe Ward, all his personal property and the family silver, which he insisted be shipped by express to Claudia's home in Rhode Island.

Immediately after the will was finalized, John began to evidence signs of mental instability—forgetfulness, disorientation and bouts of depression— unusual in a vigorous man who was not yet sixty. He sought medical care, but none of the prescribed healing methods effected any positive change. In February 1873—just nine months after marrying Eliza—he died of a (suspicious?) "brief illness," never knowing that Eliza was five months pregnant.

When her baby, Frances "Fanny" Bartow Howell, was born in June 1873, Eliza successfully petitioned John's estate for a year's support and, four weeks later, married Thomas F. Magner, an engineer aboard the steamer *Leo* plying the waters between Savannah and New York.

Her next move was to request that the court overturn John Howell's will since it included no provision for Fanny, born within the usual nine months. Her request was granted, igniting a barrage of legal fireworks.

Claudia, John Howell's "only child" and "next of kin," petitioned the court to be named administratrix of the revised will, and over the objections of Thomas Magner, her stepmother's new husband, she was duly bonded. The battle lines were drawn.

Claudia claimed that on the basis of an April 1873 appraisal, the court agreed to a $50-per-month year's support for both Eliza and Claudia—an amount that Claudia had never claimed, having by then turned twenty-one. She further maintained that since Eliza had married Thomas Magner in July, she was no longer entitled to a year's support, but at best only about four months. Furthermore, since Howell's death, Eliza had continued to live in a house belonging to the estate without paying any rent, which would

have totaled more than the $200 to which she was legally entitled. Given these circumstances, Claudia requested that Eliza's petition for $50 a month be set aside. She also objected to support for the child, citing that Fanny didn't exist at the time of John's death and that the request for her support was unreasonable and excessive, especially since there were debts against the estate.

Eliza's new husband counterpetitioned the court, requesting the appointment of an impartial appraiser to determine an appropriate amount of support for Fanny. When the resulting appraisal confirmed debts of $600 against John Howell's estate, the court ruled that Claudia, as administratrix, could sell sufficient real estate to defray the debts. She sold the lot in Gaston Ward left to Eliza in the original will and retained the lot and cottage at 517 East York Street.

At the support hearing the doctor who attended Eliza during Fanny's birth testified that he had also treated John B. Howell for "instability of mind" during the six months prior to his death. He maintained, however, that Howell was *compos mentis* (sane) at the time he made his will and that, though "enervated," he was otherwise able to perform the ordinary functions of a man. He testified that Eliza had told him she was *en ciente* (pregnant) prior to John's death and that the child arrived full term. Little Fanny Howell was granted support in June 1875.

As soon as an Act of 1876 allowed married women to serve as guardians for minor children by former husbands, Eliza Josephine Miller Howell Magner successfully petitioned the court again, this time requesting letters of guardianship for Fanny, now three years old.

That spring Claudia, perhaps wishing to be rid of her avaricious stepmother once and for all, deeded 517 East York Street to Eliza for $5 representing full settlement and release of further claim upon John Howell's estate. Eliza promptly sold the cottage to Francis M. Threadcraft for $1,500.

Then in September 1876, a series of suspicious events took place. Eliza became a widow for the second time when Thomas Magner, twenty-seven, died of "the vomits" and was buried in Catholic Cemetery.

Later that year, the inconvenient child, Fanny, also died of "vomit," a curious circumstance, given that eight of the ten deaths recorded on the same day were listed as caused by "yellow fever." The ninth person succumbed to "congestion."

Could the child's vomiting—as well as the father's—have been poison-induced? If so, had the poisoning been intentional?

Just eight months after Fanny's death, Eliza Howell Magner married Thomas Farley, who also died—but whether of "the vomits," we'll never know.

Howell Family

John Bartow Howell
(1817–1873)
 m.
Susan M. Timmons
(1828–1854)

Claudia Howell
(1852–1919)
 m.
 Gabriel Gahona

 m.
Hannah S. Thuron

(No issue)

 m.
Eliza J. Miller
(Magner Farley Eberhart)
(? –1826)

Frances Bartow Howell
(1873–1876)

In 1886 Eliza Josephine Miller Howell Magner Farley married her fourth husband, Augustus Eberhardt, who had worked with Thomas Farley at 41 West Bay Street.

Gus was a dashing, quick-tempered man who was once hauled into court for fighting and given the choice of paying a twenty-dollar fine or spending thirty days in jail. He was also a gifted sailor, serving as captain of the racing sloop *Neca* during what the *Morning News* described as "one of the prettiest ocean regattas known to the south Atlantic coast." Five boats from Charleston, Brunswick and Savannah competed for a first prize of $300.

Uncharacteristically, Eliza remained married to Gus until her death in 1916.

Although John Howell's daughter, Claudia, had been lucky in court, she proved unlucky in love. Described at twenty-four as possessing "graces, virtues and accomplishments in so eminent a degree," she married Spaniard Gabriel J. Gahona—a commission merchant representing the Spanish interest for Tunno & Company of Savannah.

Three years later Gahona absconded with a large amount of company money, forcing Claudia to apply for a protective "exemption of personality" from her husband's property.

Apparently soured on marriage, she lived alone for the next forty years, teaching sixth grade at Chatham Academy and Sunday School at Christ Church until her death at sixty-seven in 1919.

No doubt Eliza Josephine Miller Howell Magner Farley Eberhardt's fourth and final husband, Gus, knew Francis "Marion" Threadcraft (1827–1892), the man to whom she sold 517 East York Street in 1878. Both were avid racing sailors who competed in the regattas frequently staged off Tybee Island.

Threadcraft, a harbor pilot by trade, married seamstress Almira Blance in 1849 when he was twenty-two, and for a while the couple resided in the household of his sister Harriet and her husband, James Skinner. Almira's first child, Francis M. Jr., was born in 1851, followed by a second son, George, five years later. Sadly, little George lived only until his second birthday.

The loss of their child no doubt weighed heavily upon the couple—perhaps too heavily for their marriage to survive. By 1860, Almira Threadcraft and nine-year-old Francis had moved to separate quarters while Marion remained in the home of his sister.

Whether the Threadcrafts subsequently divorced or Almira died is unclear, but in 1865 Captain Threadcraft brought to Savannah aboard his fifty-ton schooner *Wm. E. Stevenson* the woman who would become his

second wife, Sarah Frances Coombs of New Hampshire. During their brief marriage, they lived at "the residence [Greenwich] at Thunderbolt."

Threadcraft had, by this time, ended his career as a river pilot and become proprietor of Riverside House, an eating establishment popular with other seafarers. The crew of the steamer *Oak*, for example, after a harrowing rescue off Wilmington Island on the night of May 28, 1866, were provided "benevolent entertainment" at the Riverside by Captain Threadcraft and his wife.

Marion spent the summers doing what he loved best—racing his sloop *Minnie* (named for his niece, daughter of James Skinner) in the waters near Thunderbolt. In one such race six sloops competed for "a beautiful silver goblet." The *Jane L*, in the command of Captain Aiken, took first, and *Minnie* came in second. The victory was celebrated at the Riverhouse, where the company enjoyed a sumptuous dinner on the house. Thus began a sailing rivalry that was to continue for years.

Both Marion and Sarah fell ill in late summer of 1866—probably of yellow fever—but only he survived. Sarah Threadcraft, thirty-two, died at their home in Thunderbolt. The yacht race previously scheduled for August 29 was postponed indefinitely because of Marion's illness and his wife's funeral in Laurel Grove Cemetery. Maybe grief caused Marion to advertise his two-story residence for rent, not wishing to live there without his bride of only four months.

By June 1867, he had sufficiently recovered his health and his spirits to skipper the *Minnie* to victory in the Thunderbolt Regatta with the *Jane L* taking second. And two months later he married his third wife, Georgia Roberts, settling her into Greenwich.

A new enterprise became his passion—the establishment of a horse-racing course on his own land. By March 1868, he had formed an association under the name of "The Savannah Jockey Club" to organize and control the course. Threadcraft planned to erect stables, a refreshment area and a "convenient building" for the comfort of the ladies.

The club's membership was composed of prominent city leaders who shared an interest in promoting the sport of horse racing. In April 1868, the local newspaper announced the completion of the fencing, grading and judges' stand, proclaiming it the best track in Georgia.

After the death of his beloved niece Minnie Skinner in August 1868, Marion seemed to lose his racing edge. The *Minnie* lost a $250 purse to the *Jane L* in front of a large group of spectators gathered in Thunderbolt, and Marion sold her a couple of years later. Her new captain, Ludlow Cohen of Isle of Hope, lost the championship at Beaulieu, and *Jane L* once again took the $1,000 purse, winning by nearly a quarter of a mile.

In 1873 when Savannah's German organization, the *Schutzen Gesselschaft*, sought a location on which to erect a park and club house, Captain F.M.

Threadcraft's property near Bonaventure was voted as providing the most suitable site. The membership of the SG voted to pay up to—but no more than—$8,000.

Cruel death claimed three of Georgia and Marion Threadcraft's children at the age of four—Fred Merville in 1875, Julian Burns in 1882 and Edith Mary in 1884. The fourth, daughter Georgia, died of consumption in 1891 when she was nineteen.

In 1888, four years before his death in a Fulton County insane asylum, Marion sold 517 East York Street for $1,310 to Peter Reilly, guardian of Annie Honora Smith, a minor.

Threadcraft's will bequeathed all his property and effects to his wife, Georgia, whom he appointed as executrix. But before the will could be probated, there occurred a startling turn of events. A woman named Mary Cahill Pano appeared at court, presenting herself as Marion's only legitimate child by his first wife Almira. She maintained, among other issues, that her father's will was invalid, having been written while he was insane. This claim triggered an eleven-year legal battle that cost a significant portion of the estate to resolve. During this process, the will's three witnesses attested to Marion Threadcraft's sound mental state, and Mrs. Pano's caveat was dismissed.

Meanwhile, on April 19, 1892, Annie Honora Smith, new owner of the cottage at 517 East York, married Holbrook "Thomas" Estill with much pomp and ceremony. Thomas was the son of John Holbrook "Hollie" Estill, a veteran of the Confederate navy and proprietor of the *Savannah Daily News*. He spent his childhood years in the house (now demolished) next door to the Isaiah Davenport house at State and Habersham Streets (see chapter four).

By the time of his marriage, he had joined the family newspaper business and had already established himself as an amateur actor of some note, giving acclaimed performances in the Ford Dramatic Association's productions of *Young Mrs. Winthrop* and *The Private Secretary*. In the play *London Assurance* when Charles Courtly proposed to Grace Harkaway, Thomas Estill's performance was hailed as "particularly impressive," and the audience demanded that the scene be repeated.

Prior to the birth of the Estills' three children—Helen (1895), Clara (1900) and Stewart Anthony (1902)—Annie sold the cottage at 517 East York Street to Dennis Shea (1825–1911) for $1,310.

Four facts are known about Dennis Shea—that in 1867 he built a pretty cottage now known as 530 East Gordon Street; that he once served as special duty sheriff during the October 1872 election; that in 1910 he owned 140 Price Street (see chapter six); and that when he died in 1911 at age eighty-five, he left four properties to his sole heir, Jeremiah P. Shea: the cottages at 505 and 507 East Saint Julian Street (now demolished, but once adjacent to the cottage discussed in chapter one); part of a lot in Greene Ward; and the little crooked house at 517 East York Street.

In 1913 Jeremiah P. Shea sold the latter for $3,700 to a man of color, Thomas M. Holly (born 1871), who made his living as a realtor and bought the property as an investment. He owned a home on Oglethorpe Street where, in 1930, he lived with his wife, Hattie; his elder brother, John; and a six-year-old nephew, George Horne.

After thirty years of ownership, Holly sold the little crooked house at 517 East York Street in 1945 to current Savannah residents. It changed hands again in 1952, 1974 and 1976, its various owners still living in the area.

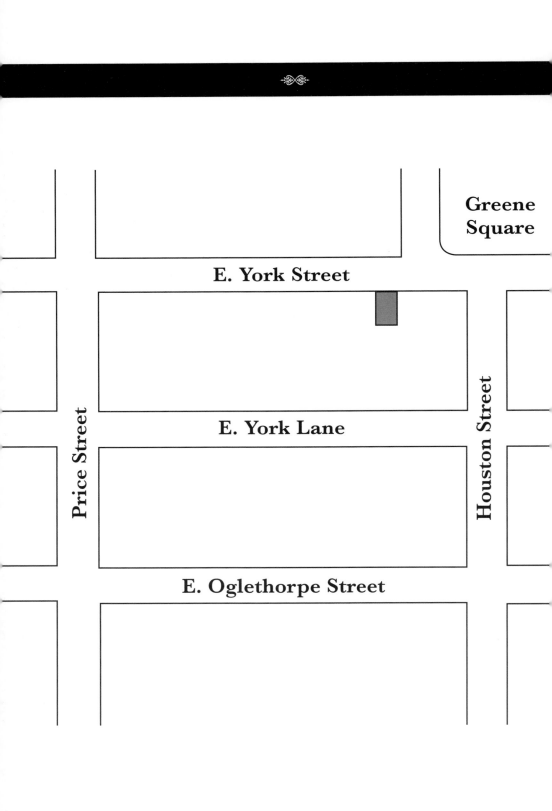

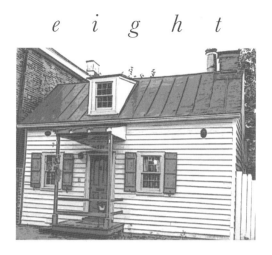

519 East York Street
Greene Ward

Beside Susannah Clarke's cottage at 517 East York Street stands number 519, built for Edward White (1758–1812), a native of Brooklyn, Massachusetts. He came to Savannah about 1785 following his tour of duty in the Revolutionary army, during which he achieved the rank of major. Because his name appears in the 1790 (earliest surviving) county tax records, we know that by the time he married Mildred "Milcey" Scott Stubbs in 1792, he already owned property.

Together, Edward and Milcey White produced two sons—Thomas and Benjamin Aspinwall—and a daughter, Maria Susannah. Edward, a plantation owner, invested wisely and provided well for his family. When, for instance, the city council passed an 1806 ordinance dividing part of the east and west commons into lots to be sold to the public according to certain terms and conditions, Edward White purchased property in the newly formed Greene Ward and put it in trust for Maria

Susannah. The cottage on this lot, now known as 519 East York Street, was erected in 1812.

Major White invested his energy in Savannah's future, serving his adopted city in a number of important ways—as captain of the watch and city guard, as "Register of Probates" for Chatham County, as superintendent of several aldermanic elections and, toward the end of his life, as inspector for the Port of Savannah.

By 1800 he had been commissioned as county clerk of the Court of Ordinary, a position he continued to fulfill without difficulty for several years, unaware that dark forces were gathering against him. Three justices of the inferior court—Edward Telfair, John H. Morell and A.S. Bullock—decided to oust Edward White as county clerk and to install their friend Thomas Bourke in his place. So in February 1807, they began systematically harassing him. According to the *Columbian Museum and Savannah Advertiser*, they made unreasonable demands, questioning his competence and generally pressing him into "servile acquiescence to their service."

After three months of such abuse, they managed to trump up false charges of contempt—at a cost to Edward of great personal indignity. He had had enough. In May he dutifully delivered the papers and records belonging to the court and left office. Thomas Bourke was installed as county clerk, and the three justices celebrated their victory. But Edward White had fought bravely in the Revolutionary War. He knew about battle strategy and had faced far more dangerous adversaries. This was a matter of honor, and he was not about to quit without a fight. He immediately appealed to the State Legislature, supplying all necessary testimony and documentation, and prepared himself to abide by its decision.

At the November 1807, meeting of the House of Representatives, the assembly heard his petition, examined the constitutional law pertinent to the case and rendered their decision. Since he had been "appointed, commissioned, and qualified" by the governor, he could be removed from office only by means specified in the constitution and thus must be reinstated as county clerk. Advantage: Edward.

The three justices, however, decided to ignore this resolution. They allowed Thomas Bourke to continue in office for six more months. Deuce.

By the time the legislature met in May 1808, Justice Telfair had died. In that session, a resolution passed forty-three to ten to remove the remaining two justices from their positions on the inferior court of Chatham County and to reinstate Edward White immediately as county clerk. The legislators recommended that he sue for damages against

those responsible for any personal injustice he had sustained before the proper tribunal.

One year after the judges acted in an "ill-judged and precipitate" manner, they were censured and removed from their offices on the inferior court.

On June 7, 1808, their successors were commissioned, one of whom was Edward Harden Jr. (see chapter one). Edward White resumed his duties as clerk of the circuit court and escheator for the County and State until his resignation in 1810 at age fifty-two. Victory: Edward.

Major White enjoyed the fraternity of his fellow man, serving as steward of the Union Society, as president of the New England Society of Georgia and as one of the original members of the Society of the Cincinnati, a "military, benevolent, patriotic, and non-political organization dedicated to the preservation of the principles of liberty, honor, and brotherhood among the officers who fought in the Revolutionary War." His hero, George Washington, had been the first to sign the membership roll and first to serve as the society's president general.

At age fifty-four, Edward White died of apoplexy (aneurysm), leaving behind a will that reflected the bitter lesson he had learned at the hands of untrustworthy lawyers. To his son Benjamin he left two lots in Columbia Ward, his double-barreled gun, his portable writing desk and his "Negro boy Peters." His son Thomas inherited his father's two city lots, office desk, single-barreled gun and "Negro boy George." To his daughter Maria Susannah, Edward left two lots (including 519 East York), his mahogany bureau and two slaves—his "mulatto wench Charlotte and Negro girl Ann with all their issue and increase."

The will stipulated that before his daughter "intermarried," his executors must be notified in order that a document could be prepared protecting her property for her sole use and purpose. Without such notice, Maria was to forfeit all rights to his estate.

To his wife Milcey, while she continued to be his widow "and no longer," he bequeathed $200 per annum in quarterly payments "for her comfortable support" as well as the privilege of occupying his house—providing she paid rent to her son Benjamin, who would then own it. She also received Edward's horses, "riding chair" and household furniture.

In a final gesture of mistrust, Edward White stipulated that should his wife demand more than he directed, she was to receive "no part of his estate," thus protecting her from "person or persons" who might use "artful persuasion to involve the estate in law at her expense."

In the presence of representatives of the Union Society and the Volunteer Corps of Savannah, Major White was buried in Colonial Cemetery with full military honors.

In 1825 when she was twenty-five, Edward's daughter, Maria Susannah White, "intermarried" Francis V. DeLaunay, Esq. (1803–1844) and moved to Baldwin County, Georgia. Over the next fifteen years, the couple had seven children: Francis L. became a doctor, married Anne M. Gachet and died of consumption; Emelie married Joseph Nisbet; Susan Mary became Mrs. Benjamin T. Hunter; George died in 1861 of "camp fever" while serving in the military; Edward died at Gettysburg; Cephalie married G. Elmore Burgesse; and Pauline became Mrs. Lafayette Carrington.

Although he practiced law in Milledgeville, Francis V. DeLaunay had political ambitions and was pleased to be selected to represent Baldwin County at the anti-Van Buren Convention at the statehouse in 1836. Later that year, he joined his brother-in-law Benjamin White and six others in the purchase of a beautiful parcel of land about three miles north of the ruined village of Roanoke in Stewart County, Georgia, on which they proposed to build a town to be called Liverpool. It is doubtful that the project succeeded, however, since Liverpool is absent from maps of Stewart County.

Francis's political ambitions were realized when he was elected mayor of Milledgeville in 1837. He died seven years later at age forty-one, leaving behind his "consort" (wife) and seven minor children. Maria Susannah died ten years later of cancer leaving behind four minor children. She was fifty-four.

In the estate settlement, her executors deeded 519 East York Street to Owen O'Rourke (see chapter seven), who had leased the cottage for his own use since 1835.

O'Rourke's granddaughter, Tullulah Theus (1856–1898), married David A. Lebey in 1875 when she was nineteen—a decision she would live to regret, for her new husband soon began to evidence signs of mental instability. Within three years his illness became so acute that he had to be confined in the State Asylum in Milledgeville.

Then on a steamy August night in 1878, Benjamin D. Morgan, one of Chatham County's most experienced constables, was brutally attacked by an "alleged lunatic" while patrolling his beat. David A. Lebey, who had escaped from the asylum about six weeks before, had returned to his mother's house on Harris Street where Tullulah was staying and had become so enraged with jealousy over his wife that a concerned neighbor, fearing for the safety of his own family, applied to the Court of Ordinary to issue a warrant for Lebey's arrest. By that time Constable Morgan was dead.

The outraged public charged Milledgeville Asylum with "criminal neglect" in allowing a dangerous lunatic to roam at large, eliciting the following response by the superintendent in a letter to the editor of the *Morning News*: "We have no prison house here, no chains or handcuffs, and should esteem it inhuman to use them in the treatment of insane persons. We had no reason to regard Mr. Lebey an especially dangerous lunatic and therefore allowed him to come out of the ward and walk in the grounds," at which time he made his escape. Six months after he was returned, the superintendent explained, Lebey effected a second escape by picking the lock of the door with a wire.

Even though Lebey was arrested for murder, the solicitor general, satisfied that the defendant was insane at the time, ordered a nolle prosequi (agreement not to prosecute) and ordered him returned to Milledgeville Asylum. Tullulah immediately divorced him.

During this time Owen O'Rourke died, and his heirs, including granddaughter Tullulah, deeded his home at 519 East York Street to Mrs. Margaret McDonald in 1878.

Tallulah never remarried. Twenty years later, she died at age thirty-eight, leaving all she had in the world to her brother and sister—$92.64 apiece. Her ex-husband remained hospitalized until his death in 1934.

At the time Margaret McDonald (1839–1903) purchased the cottage at 519 East York Street, she worked as a grocer, at the corner of Price and Hall Streets. But she had ambitious plans for her own future. In 1881 she moved her business to the northwest corner of York and Houston, and two years later she obtained a permit for a masonry structure to be built on the southwest corner to serve as a family grocery with living quarters on the second floor (see chapter seven). Today, 221 East York is part of a contemporary private residence facing Houston Street.

Until the new building was completed, Margaret and her new husband, Timothy Flaherty, lived in the cottage next-door, number 519.

Little else is known about Margaret McDonald Flaherty. She died in 1903 at age sixty-four, leaving the cottage and all her cash to her niece, Mary E. Harney Reynolds, whose husband John was named executor. The rest of her real and personal property went to Timothy.

John Reynolds (1856–1908), a house painter for the firm of A. Furrer, had married Stephen Harney's daughter, Mary Elizabeth, in 1882, and by the

time they inherited Margaret Flaherty's cottage, the couple had four children: John M. Jr., Margaret (named for Mary's Aunt Margaret), Mary Harney and James D., who lived to be three. A fifth child, Katie, died in infancy.

Like many immigrants who had escaped the poverty and famine of Ireland, John anguished over the suffering of his countrymen. Thus he and other members of the Irish Jasper Greens contributed generously to a relief fund, which raised $4,533—a significant sum in the 1880s. He and his family also attended St. Patrick's Roman Catholic Church, where John belonged to the Total Abstinence and Benevolent Society.

The deaths of his own two children may have motivated John to join the two-hundred-member Citizens' Sanitary Association, organized in 1881, which divided the city into seven districts to improve health conditions and thereby reduce deaths by maintaining proper sanitation and preventing the spread of disease.

When John died in 1908, Mary moved her family to 137 Houston Street, subsequently selling the cottage at 519 East York. All three children contributed to the family coffers working as clerks—John Jr. at J.H. McFadden and Bros., Margaret at Ensel-Vinson Company and Mary H. at Bell Telephone.

Their mother died in 1936 at age seventy and was buried in Catholic Cemetery next to her husband, her two babies and her aunt, Margaret Flaherty.

The man who bought 519 East York Street from Mary Reynolds in 1918 for $4,000, John Ohsiek (1899–1942), worked as a photo engraver for the Dixie Engraving Company. He and his wife, Margaret, had two sons—John Jr., who became an accountant, and Frederick, who died of accidental poisoning prior to his first birthday. The family never lived in the cottage on York Street but maintained a home at 1725 Whitaker Street.

At the time John Ohsiek Sr. died around 1943, his wife and children were also gone, leaving his daughter-in-law, Anna Wolf Ohsiek, wife of John Jr., and her daughter Anna Jr. as his only heirs. Anna, a teacher at Richard Arnold High School and secretary-treasurer of John Wolf Florist (still an active business on Waters Avenue), inherited 519 East York Street, which she retained until 1971.

By then Major Edward White's little crooked house was 169 years old, and time had taken its toll. Like many of Savannah's old houses, it

needed immediate attention to save it from further decay. Fortunately, that champion of historic preservation, Stella Henderson (see chapter five), purchased it from Anna Ohsiek, ensuring that another of Savannah's little crooked houses would be saved.

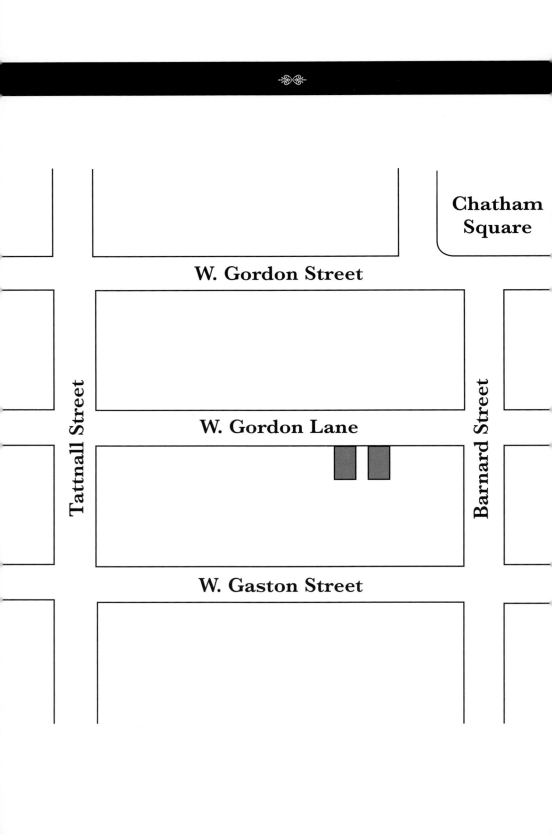

Chatham
Square

W. Gordon Street

Tattnall Street

W. Gordon Lane

Barnard Street

W. Gaston Street

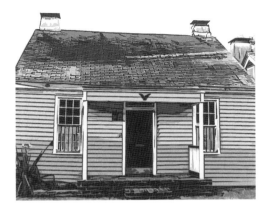

206 and 208 West Gordon Lane
Chatham Ward

In Savannah's collection of antebellum cottages are two similar, but not identical, little crooked houses built side by side on West Gordon Lane. Both follow the architectural tradition established in the eighteenth century: a central front-to-back hallway dividing the single story into equal east and west halves, each half divided into two rooms. Constructed of heart of pine, the small rooms are now used as living room and dining room in front and two bedrooms in back. Once upon a time, the only source of heat was provided by four corner fireplaces, but during a thorough renovation in 1982, central heating and air conditioning, as well as two full bathrooms and a small modern kitchen, were added. Like all such cottages, they afford more living space than would appear when viewed from the exterior.

Savannah's Little Crooked Houses

Because Savannah's lanes are, essentially, alleys, there are few trees or other greenery, no curbs or sidewalks. But beyond each rear door of these two cottages is a charming patio with a brick enclosure affording a measure of privacy from the back windows of larger houses facing Gaston Street.

Although they were not built until 1853, their story begins six years earlier when an 1847 city ordinance converted part of Savannah's South Commons into sixty-by-one-hundred-foot lots. Philip M. Russell (1816–1902) acquired one of them and built for his large family a two-story masonry house that still stands on the north side of West Gaston Street.

The Russell dynasty, whose business was law enforcement, influenced Savannah's history for more than half a century. It began in 1834 when Philip and Elizabeth C. Ferre were married in a Lutheran ceremony. Over the course of the next twenty-seven years, the couple would produce ten children, two of whom died during childhood.

A vigorous man with a lively intellect, Philip Sr. was quick to establish himself as a force in the community. He joined the Young Men's Democratic Society and took two turns serving on the board of health for South Oglethorpe Ward. In 1850 the city council elected him city constable.

The lane cottages were not yet built when fire erupted in Philip and Elizabeth's home early in the morning of April 25, 1850. Once the children were dispatched to various neighbors, friends of the Russells struggled to save as much of the house's contents as possible. Two days later the *Daily Morning News* printed a letter of thanks from Philip to all who helped to safeguard his public records and to move his family and furniture to safety. Such kindnesses, he promised, would be long remembered and gratefully reciprocated.

The city's 1851 agreement to sell twenty feet of the south common to each lot holder on the north side of Gaston between Drayton and Tattnall Streets (and to shift Gaston Street twenty feet farther south) no doubt inspired Philip Russell to build two tenement cottages on the back of his property—now known as 206 and 208 West Gordon Lane. A few years later, he put the entire lot in trust for his wife Elizabeth and their children.

A second fire threatened the Russell residence in 1853, and again Philip publicly expressed his thanks, especially to those who saved his outbuildings—probably the two cottages—and thereby kept the flames from spreading to his house.

By 1855 Philip Russell had became a judge of the city court, a position that paid about $1,000 per year, and he quickly discovered that maintaining justice was not an easy job. Slaves often became disruptive, such as the occasion when one named Bob Saulsbury threw a brick at another slave named Judge, knocking him from his horse. Bob then stabbed Judge in the back with a knife.

Russell Family

Philip M. Russell
(1816–1902)
m.
Elizabeth C. Ferre
(1819–1886)

m.
Eliza P. ?
(1840–1925)

Elizabeth E. Russell
(1838– ?)
 m.
 Charles White

Sarah L. Russell
(1840–1882)
 m.
 Andrew Aylesworth

Philip M. Russell
(1841–1890)
 m.
 Leila M. Cook

Isaac Newton Russell
(1844–1884)

Richard W. Russell
(1847–1888)
 m.
 Emma ?

Mary S. Russell
(1850– ?)
 m.
 ? Tubersing

Margaret S. Russell
(1852–1853)

Waring Russell
(1855–1914)

Perla Russell
(1858– ?)
 m. Francis E. Mendel (1876)
 m. James A. Sawyer (1889)
 m. ? Pedrick
 m. Hanse A. Hansen (1937)

Thomas E. Lloyd Russell
(1861–1867)

The wounded man, got to his feet and ran a few yards before falling dead. Shortly thereafter Philip Russell, with the assistance of the police, arrested Saulsbury at the home of his master and hauled him off to jail.

On another occasion a slave by the name of Andrew was charged with stabbing a fellow slave named Hercules. Judge Russell found Andrew guilty and sentenced him to receive "three times thirty-nine lashes."

While Phillip dispensed justice from the bench, his brother Waring Russell enforced the law as a second lieutenant on the police force—that is, until one day his superior, Captain Bryan, saw fit to bring charges against him. He claimed that Lieutenant Russell, while he was on duty, did not interfere when a police private used profanity when addressing a police sergeant. As a result the captain, with the permission of the mayor, suspended Waring from duty. Incensed, Waring hired an attorney, who contended that without the sanction of the city council, the mayor had acted inappropriately. The court agreed, and Waring was reinstated without a fine. Two months later, he resigned from the police force and was elected sheriff of Chatham County.

It was commonplace in the mid-1800s for minors to marry. Two of Philip Russell's daughters wed while still in their teens—Sarah, fifteen, married Andrew Aylesworth, and Elizabeth, seventeen, married Deputy U.S. Marshall Charles Joseph White from Baltimore. Neither was old enough to understand what their mothers knew too well—that they would likely be confined to their homes; expected to perform endless sewing, cooking and cleaning; and burdened with an average of five to seven children. For their bridegrooms, on the other hand, marriage would be a more positive experience, for it meant maid service, pampering and sex—at last.

Sarah and Elizabeth's brother Isaac distinguished himself during the Civil War as a commander of Company C, Sixtieth Georgia Regiment. It was his sad duty to report the loss of fifteen of his men killed in the battle of Fredericksburg in 1862. Philip's son-in-law Charles White also fought on the side of the Confederacy as a captain in the Sixty-third Regiment of the Georgia Volunteer Infantry.

Meanwhile, Philip did what he could on the homefront, compiling a list of indigent widows and orphans of deceased and disabled soldiers of Chatham County and arranging for them to receive support from the comptroller general's relief fund.

In 1864 the *New York Daily News* reported 900,000 men dead and buried, adding that the liberation of 100,000 slaves created a debt of over $3 billion. Savannah's *Daily Morning News* reported Georgia's death toll at nearly 10,000 and 111 of them were in Isaac Russell's regiment.

With Sherman's army on the march in May 1865, Savannah's city officials feared for the safety of the records of the Chatham County superior, inferior

and ordinary courts. In a last minute decision, the records were packed up and shipped to the state capital at Milledgeville, Georgia, for safekeeping. But as they sat in a boxcar in the Central Railroad Depot in Macon, Union forces descended on the city and savaged the train, breaking open the boxes and scattering their contents. The Honorable Philip M. Russell quickly applied for—and was furnished—a guard to protect them. As a result, these valuable records were secured in Macon with only a few papers lost.

After the bloodbath ended in 1865, Captain Isaac Russell returned to Savannah and resumed his duties as constable of Chatham County, the same year his father, Philip, was elected state representative.

In a tribute to him printed in the *Savannah Daily Herald* of March 1866, Philip was described as a fifty-year-old man of Jewish descent with a dark complexion, dark hair and black eyes. It noted that his ancestors had arrived in Savannah with General James Oglethorpe and had been among the first to settle there. It listed Philip's many positions of service (Inspector of the Customs, U.S. Deputy, U.S. Marshall, Deputy of the United States and Circuit Courts, Clerk of the City Court and City Marshal) and lauded his charitable efforts to the poor.

Modern-day historians owe Philip Russell a debt of gratitude, for during his tenure on the State Legislature, he introduced a bill to the House of Representatives providing for a Keeper of the Executive Archives whose duty would be to collect, index and preserve official records and papers.

How humiliating for such an upstanding citizen to be denied the right to vote in the election of 1867! Outraged, Philip M. Russell protested loudly and publicly when he and twelve others were turned away from the Savannah Board of Registration despite their presenting the necessary proof of pardon that all Confederates were required to obtain from President Andrew Johnson.

In September 1874, Philip's daughter Elizabeth White was at home with her two children when a ferocious electrical storm swept across Savannah. Lightning struck the chimney of the White residence at the corner of Barnard and Gordon Lanes, hurling bricks in every direction. Fearing the house was coming down, Mrs. White grabbed her children and fled to her father's house just around the corner. Fortunately, all escaped without injury.

When the situation warranted, the Russell family presented a united and formidable front. For example, on a December evening in 1875, after Superior Court had adjourned, Solicitor General Albert R. Lamar was leaving the courthouse when, for reasons unknown he was "assailed" by Philip M. Russell—senior and junior—by Isaac and Richard Russell and by the two Waring Russells, senior and junior. A scuffle ensued during which Lamar was struck in the face by Philip Jr. The solicitor immediately

returned to the courtroom, and after describing the attack, requested that the judge order the grand jury to investigate.

Although the six Russells were charged with "riot," the case was ultimately settled, and the Russell boys were discharged upon payment of court costs.

Subsequently, some citizens even denounced the Russells as "a ring," accusing them of "packing meetings" and "controlling elections" of the Democratic Association of Chatham County. Outraged, Philip protested that the Russells had always worked for the good of the party, disregarding their own interests. On this occasion harmony was restored when General George P. Harrison called for cooperation.

By 1877 Philip Jr. and Richard Russell had formed a law partnership with offices at the courthouse, Waring Russell Sr. served as jailer, while Waring Jr. and Isaac Russell were both justices with separate offices on Bryan Street.

While father, uncle and brothers all chose careers in law enforcement, Philip's youngest daughter, Perla, made a career out of marriage. In 1876 at age eighteen, she married Francis E. Mendel. She wed James A. Sawyer in 1889, followed by "Mr. Pedrick," followed by Hanse Andrew Hansen in 1937.

Perla and her five siblings lost their mother, Elizabeth, in 1886. They turned over to their father Philip in a life estate their interests in the family home on Gaston Street. He lived there with his second wife, Eliza P. Russell, until his death in 1902.

His will requested a Jewish ceremony, attended by the DeKalb Lodge Independent Order of Odd Fellows as well as all other lodges, societies and military companies of which he was a member. The will further directed that a brick grave enclosure similar to the one surrounding Elizabeth's remains be built for Eliza in Laurel Grove Cemetery so that he might sleep for eternity between his two wives.

A puzzle concerning the Russell family is still unsolved. Records indicate that Philip M. Russell Jr. married Leila Matilda Cook in 1862. Yet when he died twenty-eight years later, he bequeathed all of his real and personal property to Julia A. Hover, his "dear friend" and the mother of his children. As executrix, Julia signed her name "Julia A. Russell," then crossed out "Russell" and wrote "Hover" above.

In 1904 all the parties with a legal interest sold lot 32, Chatham Ward—including the Russell residence on Gaston Street and the two cottages on Gordon Lane—to John Henry Heitmann for $3,450.

By the time Heitmann (1845–1918), a native of Germany, was twenty-seven, he had established John H. Heitmann & Company, a thriving grocery

business at Jefferson Street and South Broad Lane. In 1872 he successfully petitioned the city for a liquor license and opened a saloon adjacent to his grocery. Shortly thereafter he relocated from Jefferson Street to property he owned at the southeast corner of Tattnall and Gordon Lane, next door to the two little cottages formerly owned by Philip Russell.

He continued to live alone, operating his grocery and saloon and overseeing his employees—not always an easy task. One such employee, J.W. Buck, took him to Magistrate's Court to recover wages that he claimed were owed to him for four months' work. Heitmann refused to pay his salary, doubting Buck's story that he had been robbed twice of money, part of which belonged to the grocery store. Ultimately, the judge found in favor of Buck, and John Heitmann was forced to absorb the loss.

On another occasion a shooting took place at John H. Heitmann & Co. Henry Saunders was shopping for groceries when he was fired upon by Philip Guilmartin. Fortunately, Guilmartin missed his mark, and the ball passed over his victim's head. Saunders took out a warrant for his arrest, charging him with attempted murder. Whether or not he was successful in his suit is anybody's guess.

One night a Negro patron named H.P. Keever, evidently a bit over served, began throwing bricks into the barroom. Heitmann had to call the police and have him arrested for disorderly conduct.

Lonely for his homeland, John Heitmann made two trips back to Germany over the next ten years to visit family and to speak again in the language of his people. On one return voyage, he brought back with him twenty-five-year-old Matilda Lichte, whom he married in the Lutheran church in Savannah in July 1882. The following spring she traveled to Germany for the birth of her first child, Henry Frederick—named for her father—and after his birth in August, she returned to Savannah accompanied by her parents. The two families shared living quarters until 1886 when the Heitmanns moved into a house of their own at 223 West Waldburg Street.

In 1904 John bought lot 32, Chatham Ward, containing Philip Russell's masonry house on Gaston Street and the two frame cottages on Gordon Lane. However, the Heitmanns never lived there, preferring to remain in their Waldburg Street home for the rest of their lives.

Between 1886 and 1897, five more little Heitmanns arrived—Lena Alberta; Helen Elizabeth; baby Matilda Charlotte, who died of diphtheria just after her first birthday; and two sons named John Henry and John Carson. Imagine the confusion of having three "Johns" in one family!

By the time of John Heitmann's death in 1918 at age seventy-three, he had amassed real and personal property worth $27,150, a significant estate

Heitmann-Fulmer Family

John H. Heitmann
(1845–1918)
m.
Matilda C.
(1857–1923)

John Henry Heitmann ("lunatic")
(1890– ?)

John Carson Heitmann
m.
Laura L.

Lena A. Heitmann
m.
Olin Fulmer

Henry F. Heitmann

Helen E. Heitmann
m.
? Zealy

Matilda Heitmann
(1897–1898)

William Fulmer

Helen A. Fulmer

Marion F. Fulmer

Olin F. Fulmer Jr.
(? –1958)
m.
Marion H.
(1913–1985)

Walter Fulmer

Mary Fulmer
m.
Richard X. Sarvis

Judith Fulme
(1944 – ?)

Olin F. Fulme

that he left to his wife and three of his five surviving children—John Henry Jr., John Carson and Helen Elizabeth. His daughter Lena was already well provided for, having married Olin Fulmer, a wealthy Savannah businessman. Why John's eldest son, Henry Frederick—a realtor and collections agent—was excluded is unexplained.

Shortly before her death in 1923 of uterine cancer, Matilda Heitmann gave her children all her undivided interest in the property and estate of her deceased husband. When the property was partitioned, John Henry Jr. received lot 32, Chatham Ward, which included the cottages at 206 and 208 West Gordon Lane.

Matilda's own estate, worth $77,372.44, included a special gift of jewelry, household furniture and $1,700 to her daughter Helen Elizabeth as thanks for the many services she had performed during her mother's battle with cancer. Matilda's will requested that she be buried in the family lot at Laurel Grove Cemetery and that the cost ($500) of an inscribed monument to the memory of her late husband be paid from the estate. She further directed that if any of her heirs (her five children and four grandchildren) contested the will, they were to forfeit their share.

Sadly, John Henry Heitmann Jr. never enjoyed the property he inherited. At age thirty-five, two years after his mother's death, he was adjudged a "lunatic" and assigned to the guardianship of his sister Lena. She and her husband, Olin F. Fulmer (who would later serve as mayor of Savannah from 1949 to 1955) took him into their home at 524 East Victory Drive. He lived there among his nieces, Helen and Mary, and his nephews, Olin Jr., William and Walter—all of whom inherited his property at his death in 1954.

Before the distribution of John Henry's property could be made, however, his nephew Olin Fulmer Jr., age forty-four, president of the Citizens and Southern Bank at Albany, suffered a tragic death. A baseball enthusiast, he and three friends were returning home after enjoying a Major League All-Star game in Baltimore when their twin-engine Beechcraft crashed in a rainstorm near Culpepper, Virginia, killing all aboard. Olin's share of John H. Heitmann's legacy was divided among his children.

Like all of Savannah's antebellum cottages, Philip Russell's two little crooked houses had become timeworn and dilapidated over the years. Fortunately, thanks to the current owner, two more of Savannah's tiny treasures have been saved.

Notes

Chapter One

1. Named for Benjamin Lincoln, Revolutionary War general.
2. When the current owners purchased this house in 1984, delinquent ground rents totaling thirty-six dollars (six dollars per year) were owed to the City of Savannah, one of the last properties subject to this system.

Chapter Three

3. Named for General Joseph Warren, who fought and died at Bunker Hill.
4. Descendent of patriot Spence Grayson, for whom a bridge between Whitemarsh and Wilmington Islands is named.
5. Picot Floyd is credited with dyeing the Savannah River green in honor of St. Patrick's Day in March 1962

Chapter Four

6. Named for John Houston, governor of Georgia (1778 and 1784); mayor of Savannah (1789).

Chapter Seven

7. Tullulah's story continues in chapter eight.

Bibliography

Books

Census of Georgia Slave Owners, 1850. Compiled by Jack F. Cox. Baltimore: Clearfield, 1999.

Coulter, E.M., ed. *Georgia's Disputed Ruins.* Chapel Hill: University of North Carolina Press, 1937.

Cox, Jack F. *Georgia Slave Owners.* Baltimore: Genealogical Publishing, 1999.

DeLamar, Marie, et al. *The Reconstructed 1790 Census of Georgia.* Baltimore: Genealogical Publishing, 1985.

Digest of All the Ordinances of Savannah. Compiled by Chares S. Henry. Savannah: Purse's Print, 1854.

Harden, William. *A History of Savannah and South Georgia: 1844-1936.* Atlanta: Cherokee, 1981.

———. *Recollections of a Long and Satisfactory Life.* Savannah: W. Harden, 1934.

Historic Savannah: Survey of Significant Buildings in the Historic and Victorian Districts of Savannah, Georgia. Edited by Mary L. Morrison. Savannah: Historic Savannah Foundation, 1979.

Hoskins, Charles Lwanga. *Yet With a Steady Beat.* Savannah: Gullah, 2001.

Index for the 1860 Federal Census of Georgia. Compiled by Arlis Acord, et al. LaGrange, GA: Family Tree, 1986.

Jackson, Ronald Vern, ed. *Federal Census Index Georgia, 1850 Slave Schedules.* West Jordan, GA: Genealogical Services, 1999.

———. *U.S. Federal Census Index, Georgia, 1930.* West Jordan: Genealogical Services, 1999.

Johnson, Whittington B. *Black Savannah.* Fayetteville: University of Arkansas, 1996.

Lane, Mills B. *Savannah Revisited: A Pictorial History.* Savannah: Beehive, 1977.

Lawrence, Alexander A. *A Present for Mr. Lincoln: The Story of Savannah from Secession to Sherman.* Savannah: Oglethorpe Press, 1961.

Lee, F.D., and J.L. Agnew. *Historical Record of the City of Savannah.* Savannah: Estill, 1869.

Bibliography

McCutcheon, Marc. *Everyday Life in the 1800's.* Cincinnati, OH: Writer's Digest Books, 1993.

O'Hara, Constance. "Mrs. Marmaduke Floyd: A Triumphant Life." *Georgia Historical Quarterly* 52.

Piechocinski, E.C. *The Old Burying Ground: Colonial Park Cemetery, Savannah, Georgia, 1750–1853.* Savannah: Oglethorpe, 1999.

Roster of Confederate Graves. Georgia Division, United Daughters of the Confederacy, 1995.

Roster of Confederate Soldiers of Georgia, 1861–1865. Vol. IV. Compiled by Lillian Henderson. Hapeville, GA: Longino & Porter, 1959.

Roster of Revolutionary Soldiers in Georgia. Vol. III. Compiled by Ettie Tidwell McCall. Baltimore: Genealogical Services, 1968–69.

Rubin, Rabbi Saul J. *Third to None: The Saga of Savannah Jewry, 1733–1983.* Savannah: S. Rubin, 1983.

Russell, Preston and Barbara Hines. *Savannah: A History of Her People Since 1733.* Savannah: F.C. Beil, 1992.

Smith, Gordon. *Georgians in the War Between the States.* Savannah: G. Smith, 1989.

Trinkley, Michael, and Debi Hacker. *Identification and Mapping of Historic Graves at Colonial Cemetery, Savannah, Georgia.* Columbia, SC: Chicora Foundation, 1999.

Warren, Mary Bondurant. *Marriages and Deaths: 1763-1820.* Danielsville: Heritage Papers, 1968.

Wilson, Caroline P. *Annals of Georgia Mortuary Records.* Vol. III. Savannah: Braid & Hutton, 1933.

Newspapers

Atlanta Constitution, January 8, 1875.

Columbian Museum and Savannah Advertiser, July 5, 1796–September 10, 1818.

Columbian Museum and Savannah Gazette, February 1, 1820.

Columbian Museum and Savannah Intelligencer, December 24, 1802.

Georgia Republican and Savannah Intelligencer, January 13, 1804.

Republican and Savannah Evening Ledger, May 8, 1810–January 5, 1813.

Savannah American Patriot, May 1, 1812.

Savannah Daily Georgian, February 10, 1812–January 13, 1883.

Savannah Daily Herald, January 20, 1865–August 21, 1868.

Savannah Daily Morning News, January 15, 1850–March 13, 1873.

Savannah Daily News Herald, July 6, 1853–July 14, 1868.

Savannah Daily Republican, June 23, 1803.

Savannah Evening Press, August 22, 1987.

Bibliography

Savannah Georgia Gazette, March 25, 1784.

Savannah Georgian, August 29, 1820–September 7, 1841.

Savannah Morning News, July 26, 1866–July 4, 1985.

Savannah Morning Times, May 23, 1880; January 15, 1882–June 24, 1883.

Savannah News Press, October 27, 1939.

Savannah Public Intelligencer, April 29, 1808.

Savannah Republican, January 3, 1825.

Miscellany

Camden County, Georgia Marriage Records, 1787–1865. Compiled and published by Frances T. Ingmire, 1985.

Cemetery Records (Bonaventure), Vols. 1–6.

Cemetery Records (Catholic), Vol. 1.

Cemetery Records (Laurel Grove), Vols. 1–3.

Chatham County Georgia Wills, 1817–1826. Book F. Savannah: Georgia Historical Society, 1936.

Chatham County Tax Digest for 1839, 1845. Collection 5600CT, Savannah: Georgia Historical Society.

Death Register, Department of Public Health, Chatham County, Georgia.

Deed Books, Chatham County Superior Court, Savannah, GA. 1M, folio 974; 1W, folios 34, 279, 390; 2A, folio 12; 2C, folios 593–94; 2E, folio 232; 2O, folio 470; 2R, folio 161; 2T, folio 3; 2V, folios 175,183; 2W, folio 302; 3A, folio 529; 3B, folio 166; 3C, folio 245; 3L, folio 60; 3M, folio 47; 3N, folio 276; 3X, folio 132; 3Z, folio 531; 4C, folios 133, 620; 4E, folio 340; 4F, folios 504–05; 4G, folio 473; 4K, folio 197; 4T, folios 196, 199, 231; 4V, folio 515; 4W, folios 318, 320; 5X, folio 336; 5Y, folios 135, 137; 6I, folio 167; 6W, folio 61; 7H, folio 458; 7Q, folio 164; 8C, folios 260–61; 8J, folio 195; 8U, folios 136, 138; 10I, folios 147, 285; 10T, folios 179–80; 11J, folio 147; 12A, folio 174; 13U, folio 436; 14I, folio 108; 15O, folio 265; 17S, folio 286; 27X, folio 143; 41D, folio 165; 47E, folio 399; 51A, folio 60; 55D, folios 553, 564; 71U, folio 333; 86C, folio 94; 99F, folio 763; 107T, folio 77; 14H, folio 414; 14T, folio 24; 18N, folio 79; 47R, folio 59; 87M, folio 61; 107Q, folio 438; 115X, folio 575; 122K, folio 189; 125G, folio 295; 156N, folio 140; 176K, folio 98.

Estate Files, Chatham County Probate Court. B-368, D-46, D-729, F-388, G-1052, H-19, H-61, H-210, H-254, H-288, H-365, H-388, H-539, H-396, H-1027, H-1167, H-1197, L-59, L-334, L-623, O-45, O-53, O-69, R-259, R-308, R-323, R-407, O-357, T-211; T-232, W-366.

Floyd, Ida Perkins. "Family History, 1903–1950." M.H. and D.B. Floyd Papers, Collection 1308, Box 23. Georgia Historical Society, Savannah.

Bibliography

Georgia Historical Quarterly. Vols. 2, 18, 23 51, 54. Athens: Georgia Historical Society, 1917.

Georgia Marriages, 1826–1850. Compiled by Liahona Research. Bountiful, UT: Heritage Quest, 1999.

Georgia State Census. Camden County, 1850.

————. Chatham County, 1920.

————. Chatham County, 1840.

————. Chatham County, 1850.

————. Chatham County, 1860.

————. DeKalb County, 1850.

————. Savannah, 1798.

————. Savannah, 1840.

Georgia State Gazetteer and Business Directory, 1881–1882. Compiled by A.E. Sholes. Atlanta, n.d.

Index to Marriage Licenses A, D, F, G, Q. Savannah: Chatham County Probate Court.

Judgment #10826. Savannah: Chatham County Probate Court.

Marriages of Chatham County, Georgia. Savannah: Chatham County Probate Court, 1748–1852, 1806–51, 1852–77, 1877–78.

Milledgeville, Georgia Newspaper Clippings (Southern Recorder). Vol. 11. Compiled by Tad Evans. Savannah: T. Evans, 1995.

Milledgeville, Georgia Newspaper Clippings (Union Recorder). Vols. 2, 5, 6, 7, 8, 9, 11. Compiled by Tad Evans, 1995.

Parish Register, Christ Episcopal Church, Savannah.

Parish Register, Book A, St. John's Episcopal Church, Savannah.

Register of Deaths in Savannah Georgia. Vols. 2, 4–6. Compiled by the Genealogical Committee. Savannah: Georgia Historical Society, 1983.

Savannah City Code: Comprising the Statutes and Ordinances Relating to the City of Savannah. 1871. Compiled by George B. Clarke. Savannah: PRM Law Publishers, 1976.

Savannah City Directories for 1858, 1859, 1867, 1871, 1876, 1877, 1885, 1888, 1897, 1899, 1907, 1909, 1910, 1912, 1913, 1914, 1920, 1923, 1930, 1939, 1940, 1960, 1965.

Savannah Tax Digests for 1809–19, 1814–28, 1840. Collection 5600CT, Savannah: Georgia Historical Society.

Sewell, Cliff. "It's Teatime at Laura's House." *Savannah Morning News and Evening Press*, December 10, 1972.

Smith, John Henley. *Letterbook: First Georgia Regulars*. Chatham County Probate Court Microfilm Records, 1859–60, file AH-333.

"Streetviews," Manuscript Collection #1361PH, Box 13. Savannah: Georgia Historical Society.

Bibliography

Thomas Gamble Collection, *Georgia Miscellany*, Vols. 1, 6. Savannah: Live Oak Library.

Travis Index, C-1387, Savannah: Chatham County Superior Court.

Walter Hartridge Collection #1349, Box 64, Georgia Historical Society.

About the Author

Photo: Fred A. Johnson.

Susan B. Johnson is a novelist and playwright whose columns, articles, essays and short stories have found a wide audience. She lives and writes in a little crooked house in Savannah, Georgia. This is her first non-fiction book.

Also Available from
The History Press

Sentimental Savannah
Reflections on a Southern City's Past
Polly Powers Stramm

978.1.59629.140.9 • 160 pp. • $19.99

Join Savannah writer Polly Powers Stramm on a stroll down the city's memory lane, stopping along the way to visit with some of its most memorable characters, whose stories include studying—and socializing—at Savannah's beloved schools, dancing at the pavilion at Tybee Island and picking violets along the railroad tracks outside of town.

Also Available from
The History Press

A Guide to Historic Beaufort, South Carolina

Alexia Jones Helsley

978.1.59629.045.7 • 144 pp. • $19.99

Historian and Beaufort native Alexia Helsley brings the city's past to life and provides a useful guide to the city's most historic streets, buildings and neighborhoods, allowing readers to navigate their way through Beaufort while learning about its nearly five-hundred-year history. Featuring a striking collection of full-color and black-and-white photographs.

Visit us at
www.historypress.net